WITHOUT REGARD TO SEX, RACE, OR COLOR

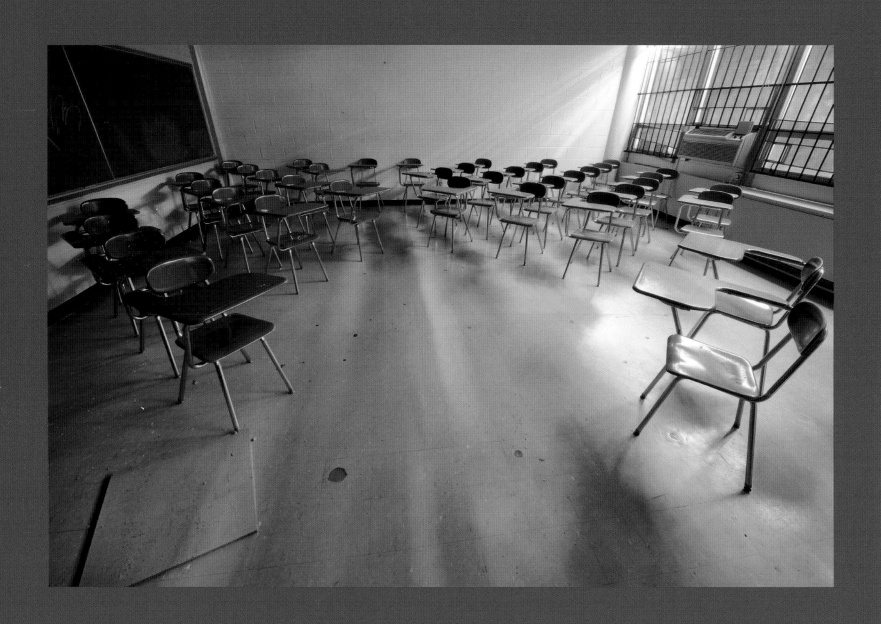

PUBLISHED IN ASSOCIATION WITH THE GEORGIA HUMANITIES COUNCIL

WITHOUT REGARD
TO SEX, RACE, OR COLOR

The Past, Present, and Future of One Historically Black College

PHOTOGRAPHS BY ANDREW FEILER

With essays by Robert E. James, Pellom McDaniels III, Amalia K. Amaki, and Loretta Parham

Especially for Sue —
Education matters
leadership matters
Art matters!
Andrew Feiler

UNIVERSITY OF GEORGIA PRESS ATHENS AND LONDON

A Sarah Mills Hodge Fund Publication

This publication is made possible, in part, through a grant from the
Hodge Foundation in memory of its founder, Sarah Mills Hodge, who devoted
her life to the relief and education of African Americans in Savannah, Georgia.

Published by the University of Georgia Press
Athens, Georgia 30602
www.ugapress.org
© 2015 by Andrew Feiler
All rights reserved
Designed by Erin Kirk New
Set in Minion
The paper in this book meets the guidelines for
permanence and durability of the Committee on
Production Guidelines for Book Longevity of the
Council on Library Resources.

Printed in Korea

19 18 17 16 15 C 5 4 3 2 1

Library of Congress Cataloging-in-Publication Data

Feiler, Andrew.
 Without regard to sex, race, or color : the past, present, and future of one
historically Black college / Andrew Feiler.
 pages cm
 Includes bibliographical references.
 ISBN 978-0-8203-4867-4 (hard cover)
 1. Morris Brown College—Pictorial works. 2. Morris Brown College—History.
3. African American universities and colleges. I. Title.
 LC2851.M88F45 2015
 378.009758'231—dc23
 2015006147

British Library Cataloging-in-Publication Data available

For my father, who taught me to step closer to my subject

And for my mother, who taught me focal point, line, movement and more . . .

and that was just in finger painting

TO ATLANTA UNIVERSITY

FROM THE CONGREGATIONAL CHURCH

SPENCER MASS MAY–1888.

——•——

DEDICATED TO THE

EDUCATION OF YOUTH

WITHOUT REGARD TO SEX, RACE OR COLOR.

FOR YE ARE ALL ONE IN CHRIST GAL. III 28.

————————

McSHANE BELL FOUNDRY.

HENRY MCSHANE & CO.

BALTIMORE, MD.

TRADEMARK.

1888.

Inscription on the bell that hangs in the tower of Fountain Hall

Morris Brown College, Atlanta, Georgia

Contents

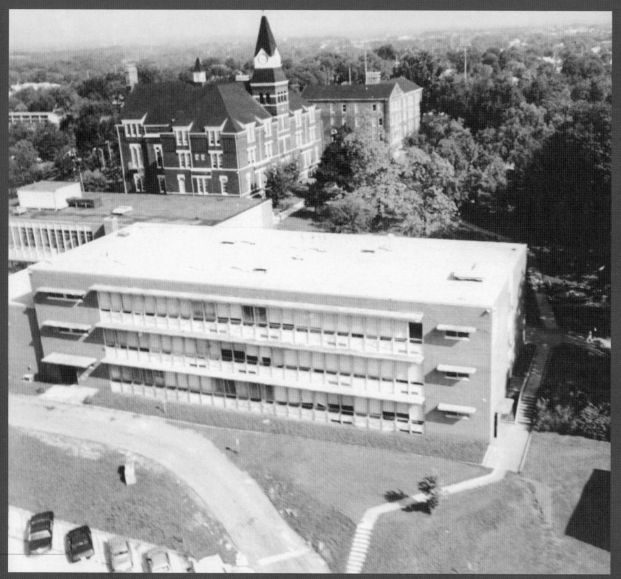

Morris Brown College campus—Griffin Hightower Center, Fountain Hall, and Gaines Hall—1986.

Dear Old Morris Brown

Robert E. James, Class of 1968

My Greyhound Bus ride from Hattiesburg, Mississippi, to Atlanta, Georgia, was a breeze since I had been on much longer bus trips during my teenage years. There was the time when one of my high school friends and I went from Hattiesburg to Los Angeles, California, to spend a week with his cousins immediately after our high school graduation in 1964. Then there were several trips to African Methodist Episcopal (AME) Church meetings, including my journey from Hattiesburg to Cincinnati, Ohio, where the Quadrennial Convention of the AME Women's Missionary Society's Young People's Division (YPD) was held. At that convention, I was crowned YPD Boy of the Year and awarded a four-year scholarship to Morris Brown College.

I was full of excitement when I reached Atlanta because I had about two hundred dollars in cash from high school graduation gifts, a full scholarship to attend Morris Brown (MBC), and almost three weeks of free time in Atlanta before I would have to register for classes. The three weeks of free time came compliments of MBC band director Cleopas Johnson, who was so determined to build the MBC Marching Wolverines Band that he had employees in the college admissions office review the records of the incoming first-year students and contact him when they saw that a student had participated in a high school band. I was a tuba player . . . a prize catch for Mr. Johnson, even though I was never much of a musician. I was a loyal but not very talented member of the Marching Wolverines Band during my freshman and sophomore years. My participation in the band led to many lifelong friendships. In fact, Mr. Johnson and I became friends, and I was told that he tried to reach me by telephone a few hours before his death in 1996.

My four years of study at Morris Brown were central to my journey from a small high school in Mississippi to the Harvard Business School to becoming the youngest bank president in Georgia (and possibly America) to becoming the African American with the longest tenure as president of a commercial bank in America. Morris Brown was a perfect match for me. Because of my experience as a leader in the youth activities of the AME Church, I was already immersed in the traditions of

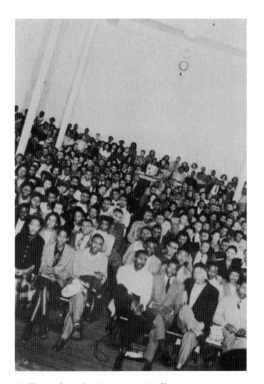

College chapel—Fountain Hall—1947–1948.

individual pride, independence, self-help, and tenacity that characterized the AME Church and Morris Brown College.

The people I met during those life-transforming years at dear old Morris Brown influenced everything that happened to me in my subsequent life. Beginning on my first day on campus, I formed friendships that have continued fifty years. It often seems as though all of us in the MBC Class of 1968 knew each other and became friends. Students who lived on campus were likely to become acquainted regardless of our classes since we ate meals together in Gaines Hall's small basement dining room. We were one closely knit family because we had so much in common. Most of us were from small-town, middle- to low-income families, and almost all of us depended on some type of scholarship, financial aid, or work-study to stay in college.

My instructors at Morris Brown were like surrogate parents or caring family members. They shared my successes and consoled me when I was experiencing challenges. Classroom professors were counselors and cheerleaders for us as students. It was not unusual to hear a science professor commend athletes when they had good

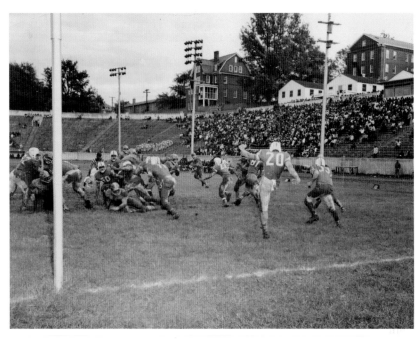

Football game—Alonzo F. Herndon Stadium—date unknown.

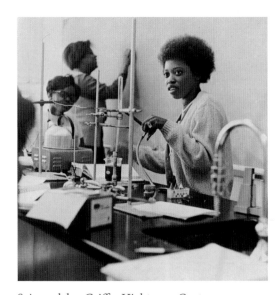

Science lab—Griffin Hightower Center—1970.

games or commiserate with them when things did not go right. I can remember the reactions of my business instructors when I told them that I had been admitted to the Harvard Business School. They were far more excited than I. They reacted like proud parents whose nurturing had paid off, telling me that I was "ready" or that I was "going to do great" more times than I can remember.

As students at Morris Brown, we had a fierce pride. It was that "old Morris Brown spirit." We believed that our experience at Morris Brown was preparing us to conquer the world. As an accounting student, I was frequently told that Morris Brown had produced more African American CPAs than any other college in the nation.

At Morris Brown, we were keenly aware of the challenges facing African Americans during the 1960s. I left Mississippi in 1964, right after Freedom Summer. Most of my classmates were the products of segregated schools in small towns throughout Georgia. Even so, we were optimistic about our futures and felt safe at Morris Brown. We were at the high points of our lives, and our campus was at one of the highest points in Atlanta. We could literally look down on parts of downtown Atlanta.

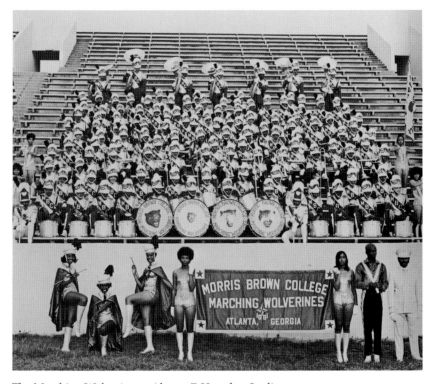

The Marching Wolverines—Alonzo F. Herndon Stadium—1972.

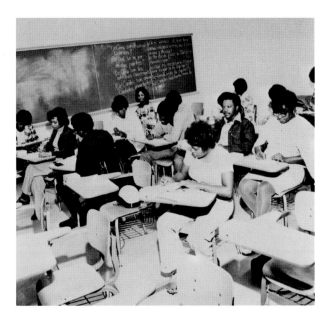

Classroom—Griffin Hightower Center—1976.

If there had been no Morris Brown College for me, I would not have been admitted to the Harvard Business School or prepared to earn an MBA degree in 1970. Without Morris Brown, I would not have met my wife of almost forty-six years, and she would not have followed me to Massachusetts, where after our first year in the area, she was admitted to the Harvard University Graduate School of Education and earned the EdM degree in 1970. Without Morris Brown, my son would not have a degree from Harvard Law School or a wife with degrees from Harvard College and Harvard Law. Without Morris Brown, my oldest daughter would not have earned the EdM degree from the Harvard Graduate School of Education, and my youngest daughter a master's degree from the University of Southern California.

The Morris Brown alma mater begins with these words:

Alma Mater, pride of earth,
Gav'st to me another birth
Haven for all hungry souls
Feeding them shall be thy goal

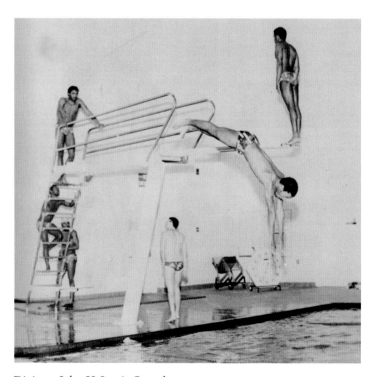

Diving—John H. Lewis Complex—1979.

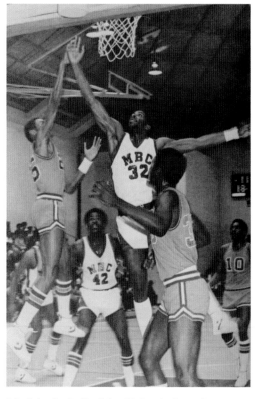

Men's basketball—John H. Lewis Complex—1979.

The Morris Brown that I and so many MBC alumni knew clearly fed our souls, which were hungry for a path to productive and successful lives. Although it is unnerving to think that there might not be a Morris Brown College to help deserving future students, I am uniquely aware of what my years at Morris Brown meant to me and my life, so I can humbly say, in the prayerful words that end the alma mater, I

bow and thank the Gracious Lord
For dear old Morris Brown.

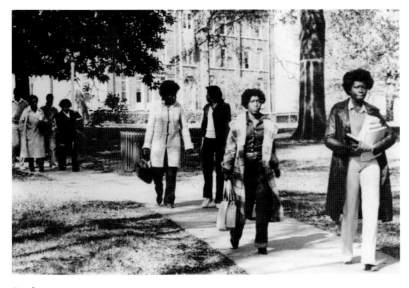

Students on campus—1980.

Dining hall—Middleton Towers—1980.

Proud Past, Challenging Present, Uncertain Future

Andrew Feiler

A large bell hangs in the clock tower overlooking the now quiet campus of Morris Brown College. Its inscription reads in part, "Dedicated to the Education of Youth, Without Regard to Sex, Race or Color." Founded by African Americans in 1881, Morris Brown lost its accreditation to financial pressures and scandal in 2002. Today its largely empty campus stands as a testament to a proud past, a challenging present, and an uncertain future, not only for this one institution but for all of America's historically black colleges and universities (HBCUS).

I was granted unique access to the hauntingly silent Morris Brown campus and spent a year shooting the photographs in this book. I sought visual moments and emotional touch points that would illuminate the stories in the college's stilled classrooms and hallways. In the resulting photographs, the *proud past* remains in the extraordinary quality of the facilities, in the school desks arrayed ready for class, in the faces of students from happier days. The *challenging present* resides starkly in the broken stained glass, the havoc wreaked by scrappers, and the hints of homeless humanity. And the *uncertain future* weighs heavily in the headlines: negotiations over the disposition of particular properties, proposals and counterproposals for restructured finances, recycled pronouncements of plans to revitalize the surrounding neighborhood. Mixed with all of these are layers of timeless emotion . . . wistfulness, pride, angst, determination, hope.

The HBCU tradition in America is indeed a proud one. Primarily in the decades of the late nineteenth century and early twentieth century, and mostly in former slave states, about 120 institutions were built with the mission of educating African Americans. Of the approximately 100 that remain, some are private, while others are part of state college systems. Some offer two-year degrees, others four. Some have an undergraduate focus, others specialize in graduate education. Collectively, these colleges and universities have trained generations of African Americans, opened new careers and opportunities, and contributed educated minds to our communities, our culture, and our democracy.

The rich and diverse history of HBCUs is reflected in the story of the bell from whose inscription this book takes its title. The land and facilities that would become Morris Brown's campus were originally part of Atlanta University, which had occupied the site, one of the highest points in the city of Atlanta, since 1869. The building in which the bell hangs was originally named Stone Hall; the bell itself was donated to Atlanta University by the Congregational Church of Spencer, Massachusetts, in May 1888. In 1932 Atlanta University was phasing out its undergraduate program, leaving vacant some of the buildings and grounds. This coincided with Morris Brown College's desire to relocate closer to the colleges—Morehouse, Spelman, and Atlanta University—that in 1929 had come together to form Atlanta University Center. With Morris Brown's move, Stone Hall was rechristened Fountain Hall; the bell remains ensconced in its original tower.

The majority of HBCUs—including each of the other schools that comprise Atlanta University Center—were founded by white philanthropists from outside the South. Morris Brown College was one of the rare HBCUs founded by African Americans. Established in 1881 under the auspices of the African Methodist Episcopal Church, Morris Brown came to be an institution noted for providing college access to the children of families with lesser means. In an America where college access for African Americans remained constrained, Morris Brown forged a tradition of providing opportunities for students whose options were further restricted by financial limitations.

As it pursued this mission, Morris Brown expanded its curriculum, its facilities, its student body, and its traditions. By the turn of the millennium, its campus encompassed over thirty-seven acres and over a dozen buildings; its student body numbered more than two thousand; its sports programs and marching band were legend; its alumni were fiercely loyal.

But over time the college's finances became increasingly precarious, and in 2002 tragedy struck. That year Morris Brown's president and another school official were charged with misappropriating federal funds to keep the school afloat. The federal government cut off student loan money; the school lost its accreditation; the student body almost entirely evaporated.

Enter Dr. Stanley J. Pritchett Sr., who in 2010 became the eighteenth president of Morris Brown College. Embracing the challenge, Dr. Pritchett has striven to sell assets, settle debts, and reconstitute the college in the historic heart of the campus.

Regardless of the outcome, he has demonstrated impressive persistency, creativity, and determination.

In considering the contemporary role of the full array of historically black colleges and universities, one set of facts is particularly illuminating: HBCUs constitute less than 3 percent of all colleges and universities in America, but they enroll more than 10 percent of all African American students[1] and graduate over one quarter of African Americans receiving college degrees.[2] In a global economy that increasingly demands higher levels of education, HBCUs remain strikingly relevant, impactful, and important. Their story is at the core of our societal quest to provide opportunity for all and to ensure the continuation of a healthy American middle class.

Still, each HBCU faces its own individual set of challenges, some specific and others more broad based. Common trends include increasingly diverse student populations, rising gender imbalances skewing toward women, lower than ideal graduation rates, and, of course, escalating imperatives for philanthropic support. The unique threats facing Morris Brown are especially daunting. They remain a matter of institutional life or death.

I was drawn to these stories because they are at the heart of the debate raging in our society today: How do we create opportunity for all in America? How do we create onramps to the middle class? How do we make all levels of education accessible, affordable, and effective? To me these are essential questions, and I ask them as a fifth-generation Georgian—actually a fifth-generation Jewish Georgian. The rich complexities of the American South, and of being a minority in the South, shape me and my art. History and culture, geography and race, tradition and conflict, injustice and progress—I carry these entangled strands within me, and they are foundational for both me and my work.

It is my aim that the photographs and words in *Without Regard to Sex, Race, or Color* will provide viewers and readers with pathways into the critical debates about our collective future. I hope that this endeavor will open minds, trigger emotion, stimulate discussion, and, perhaps, prompt action.

PHOTOGRAPHS

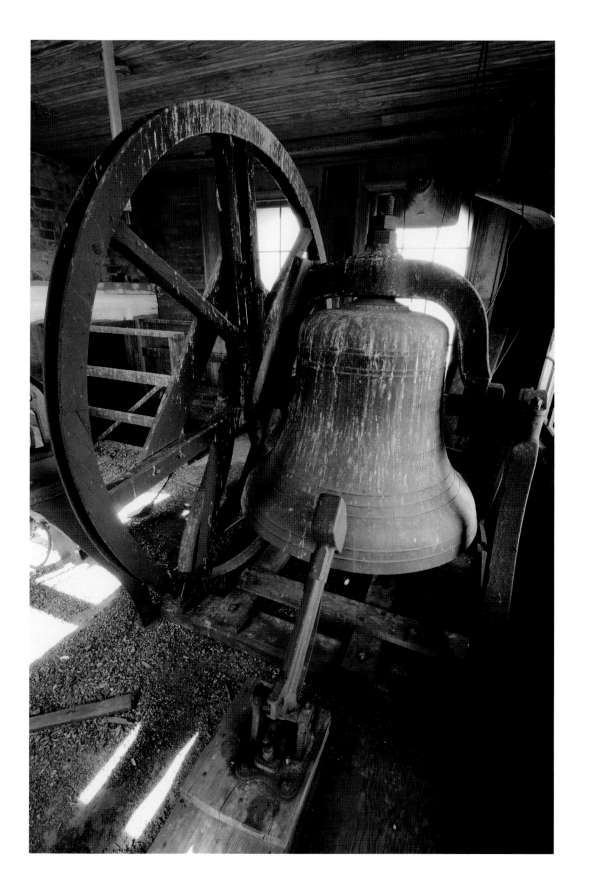

School Bell—Fountain Hall.

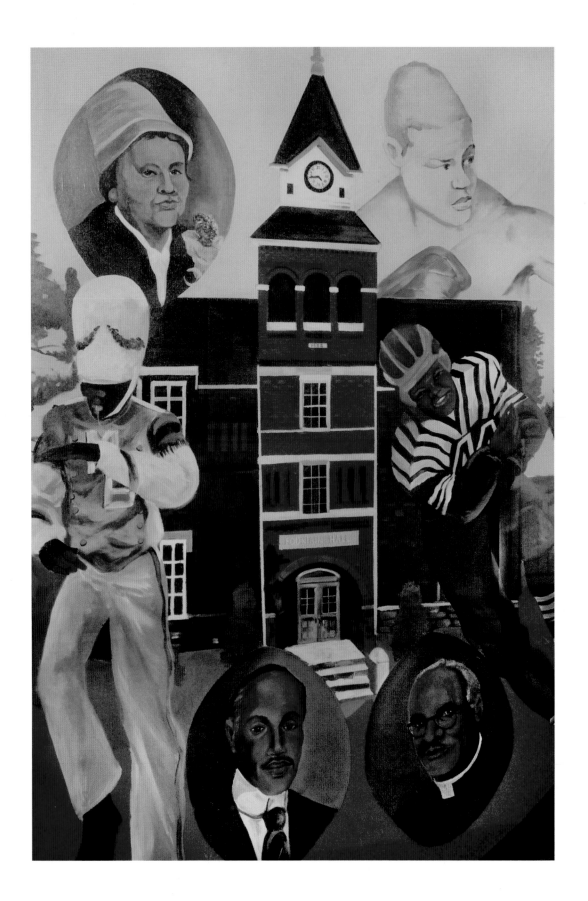

Centennial Mural—Fountain Hall.

Tower Clocks—Fountain Hall.

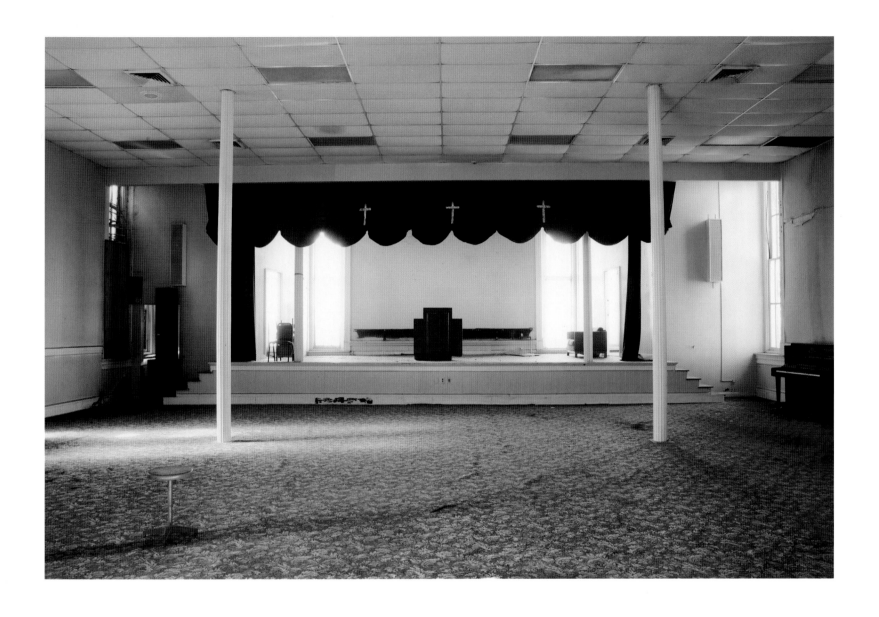

Chapel—Fountain Hall.

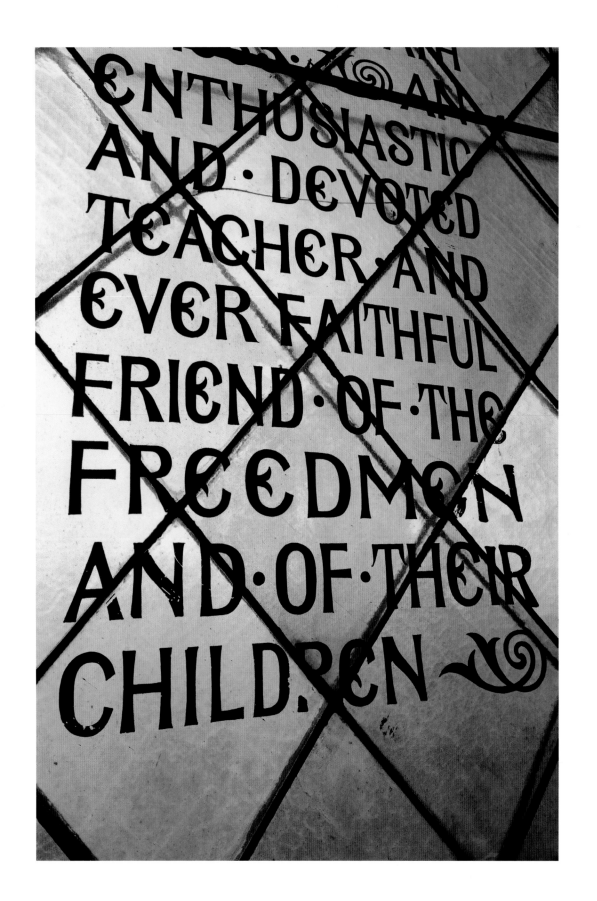

Stained Glass, Chapel—
Fountain Hall.

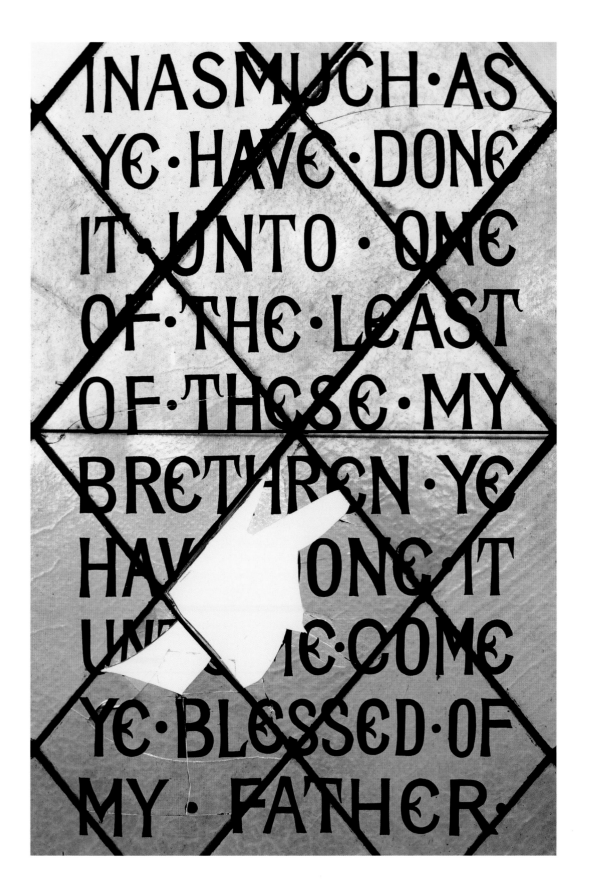

Broken Stained Glass, Chapel—
Fountain Hall.

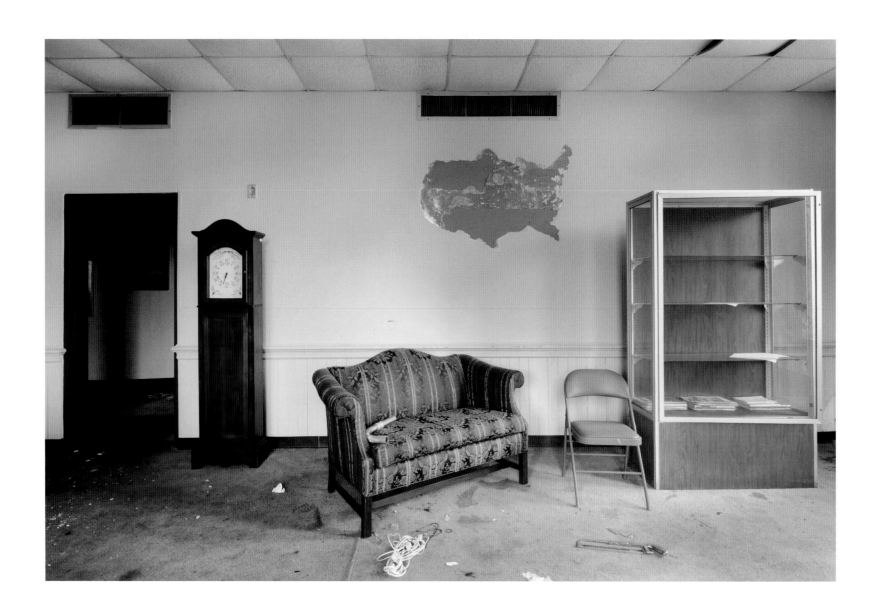

Missing Map and More—Fountain Hall.

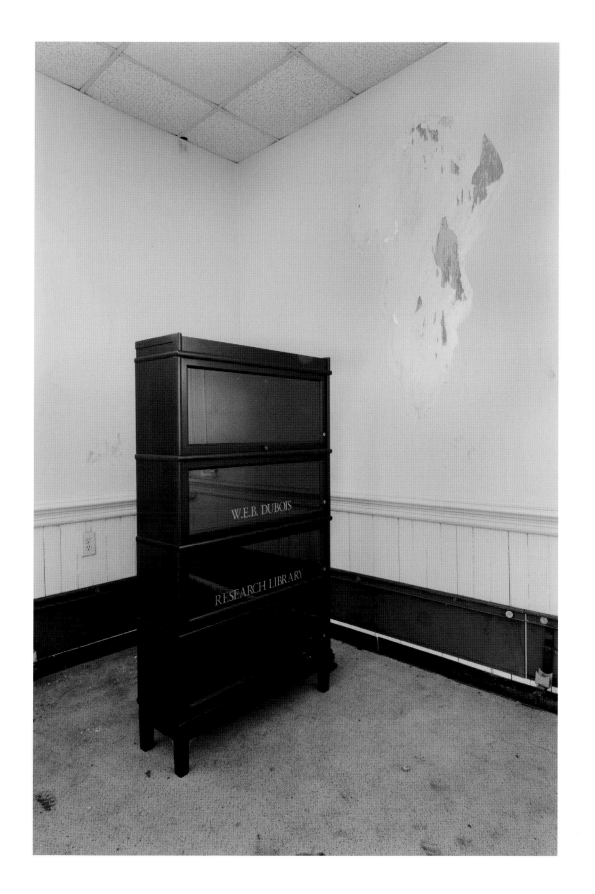

W. E. B. Du Bois Research Library—
Fountain Hall.

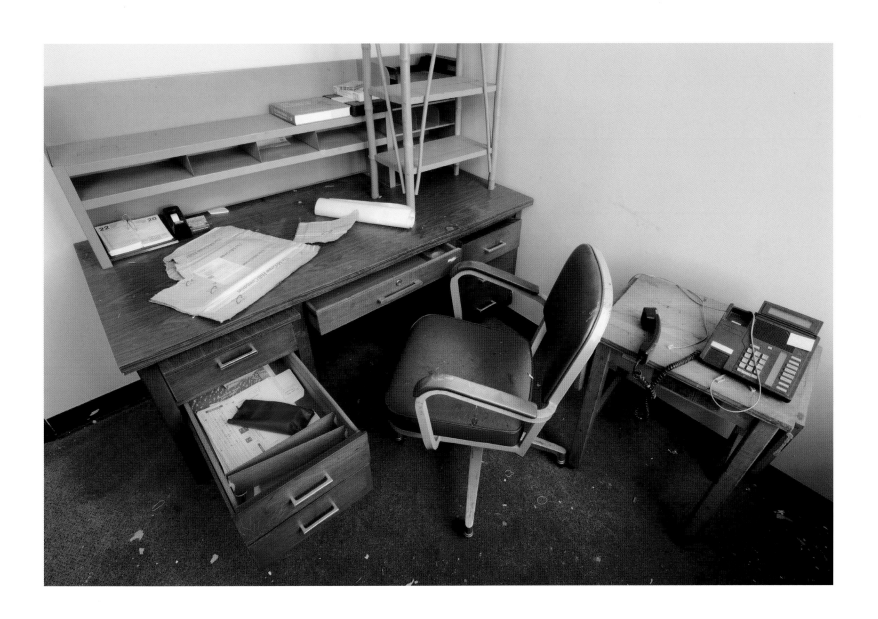

Office—Fountain Hall.

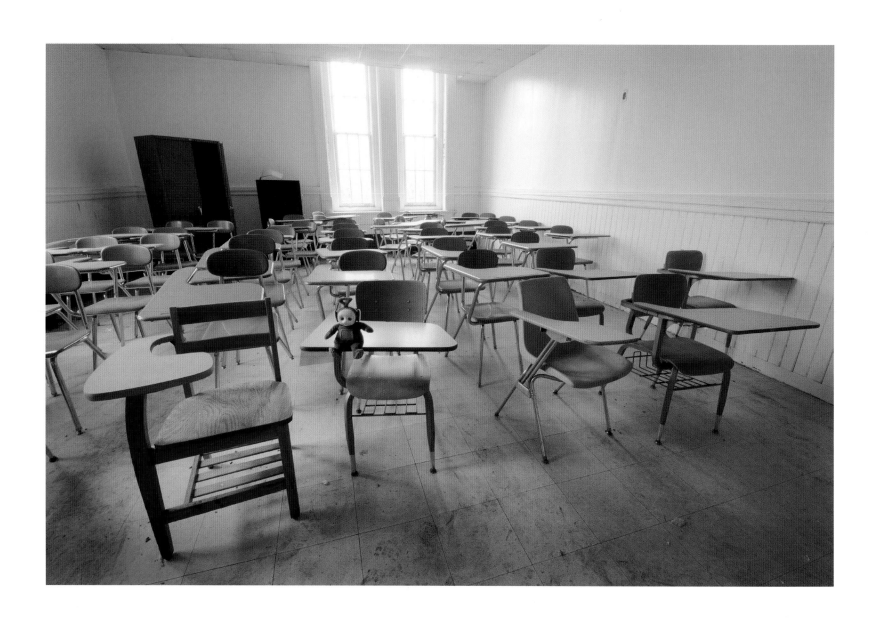

Teletubbie—Fountain Hall.

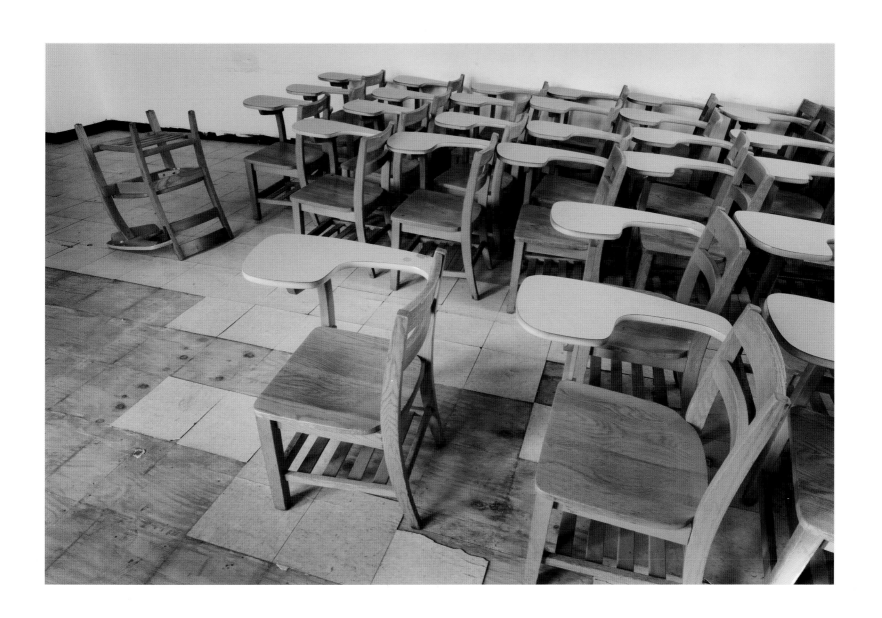

Wooden—Fountain Hall.

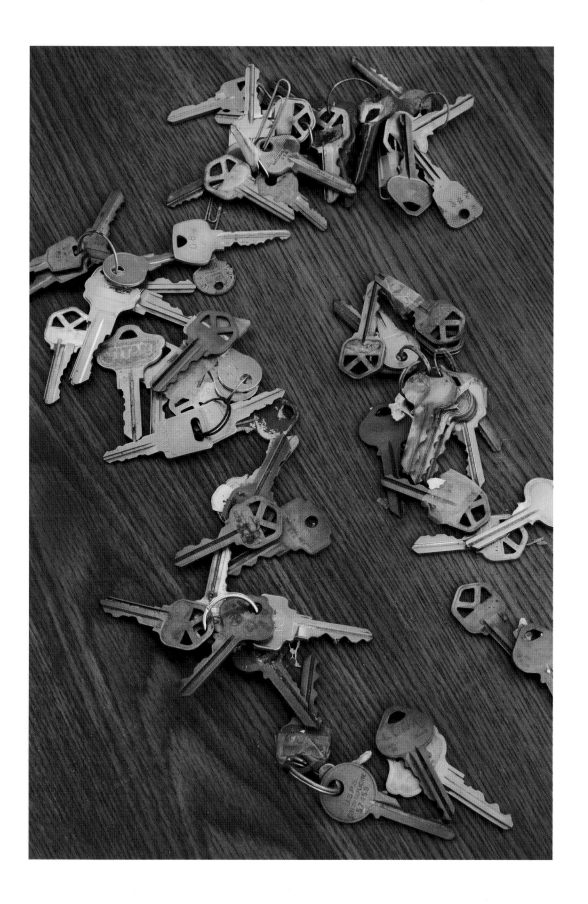

Keys—Fountain Hall.

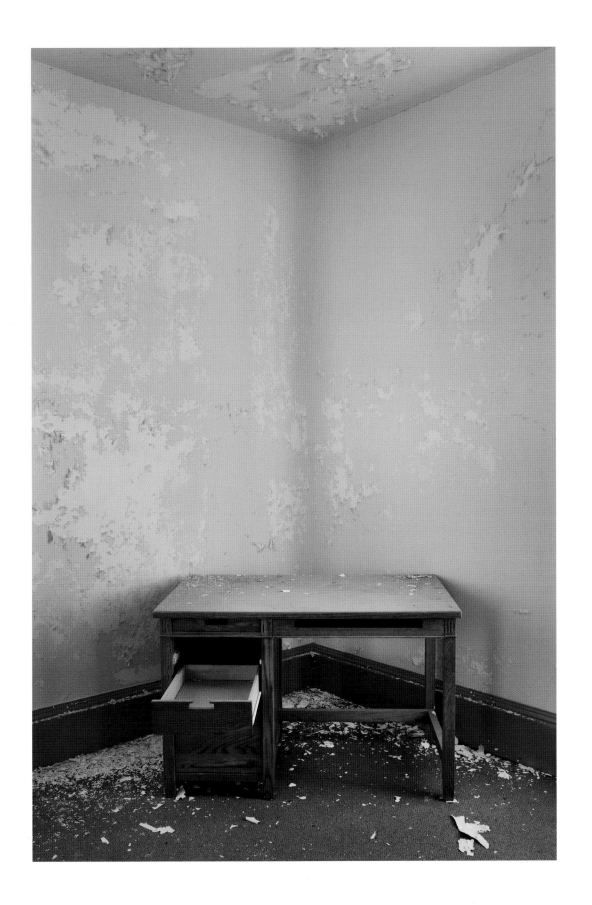

Dorm Room Desk—Gaines Hall.

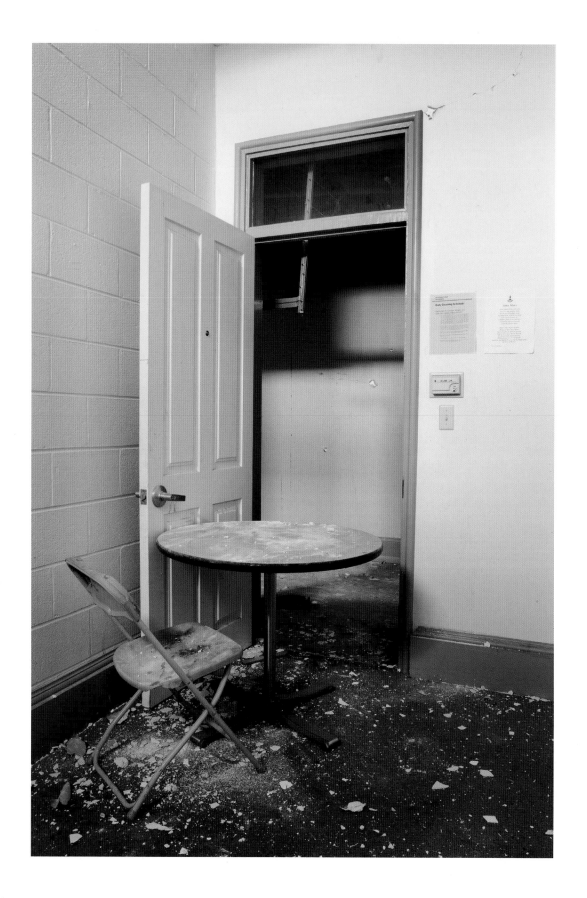

Table and Chair—Gaines Hall.

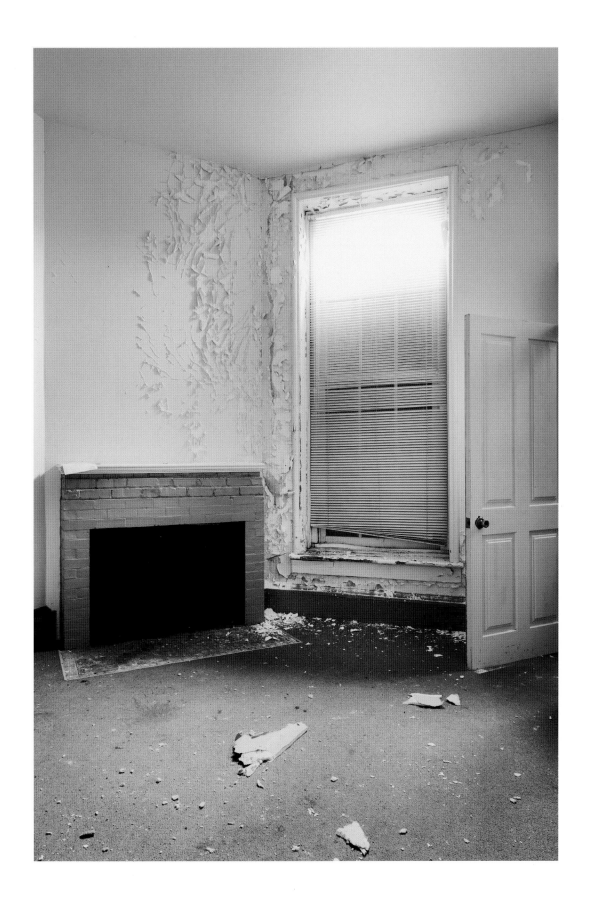

Fireplace—Gaines Hall.

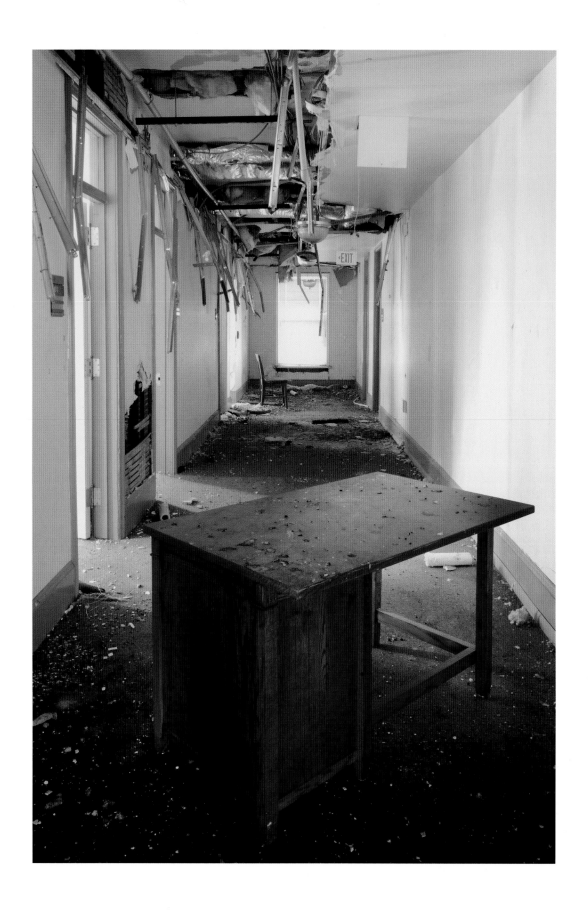

Scrappers' Work—Gaines Hall.

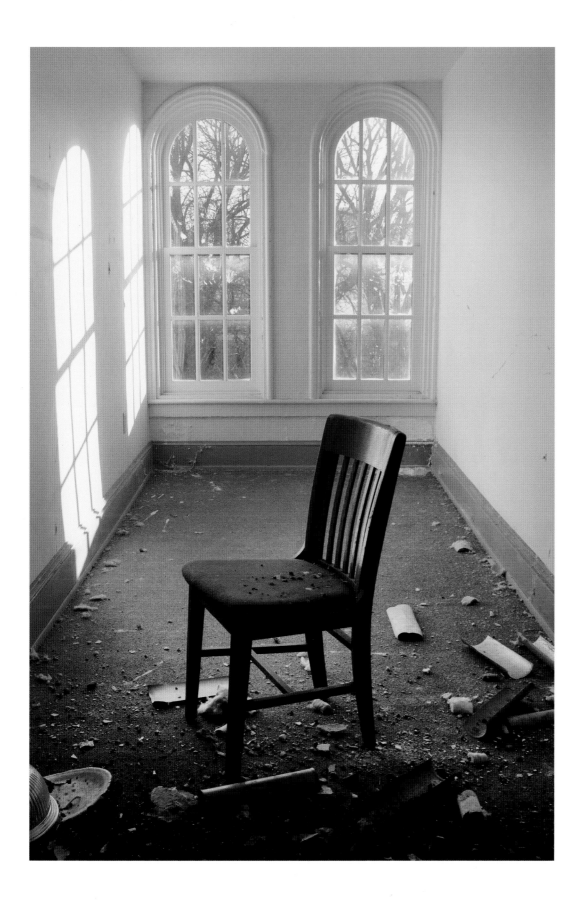

Lone Chair—Gaines Hall.

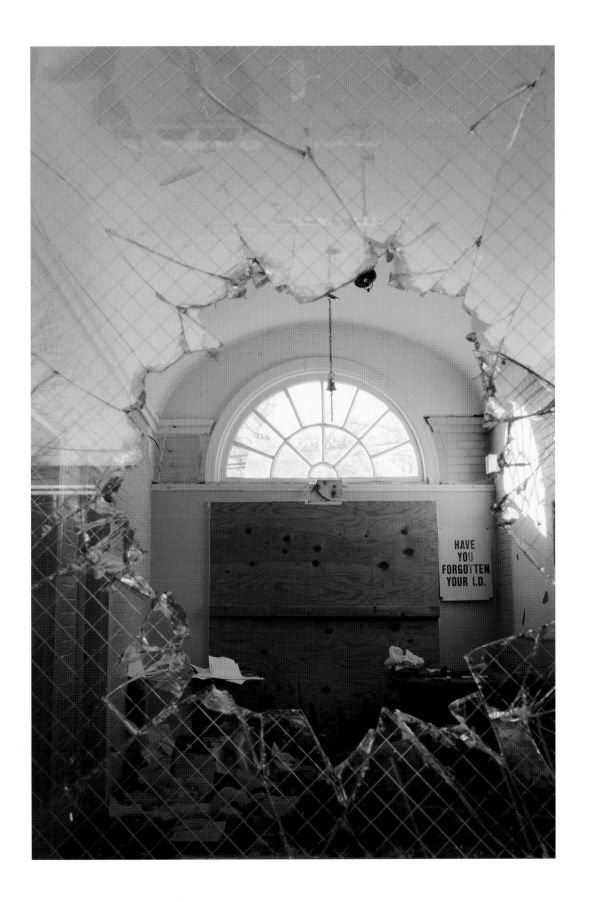

Dormitory Doorway—
Sara Allen Quadrangle.

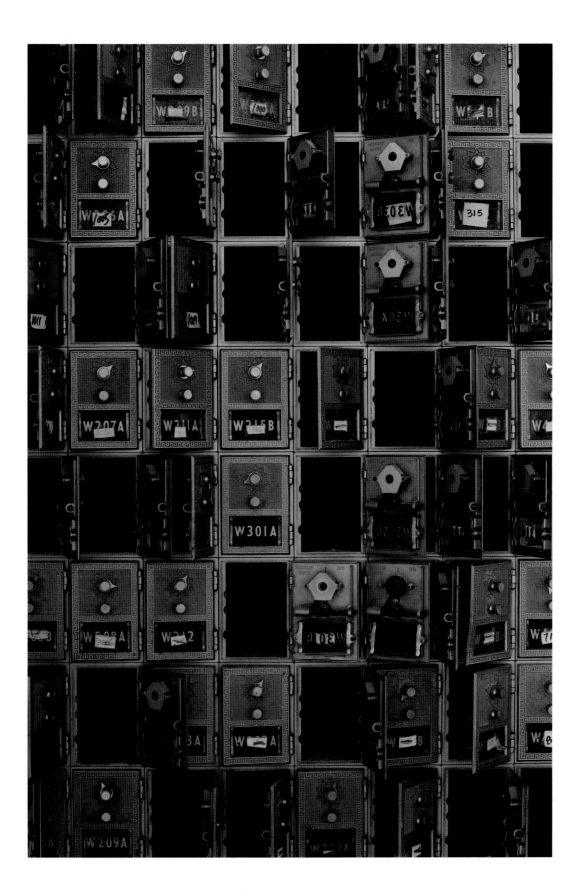

Student Mailboxes—
Middleton Towers.

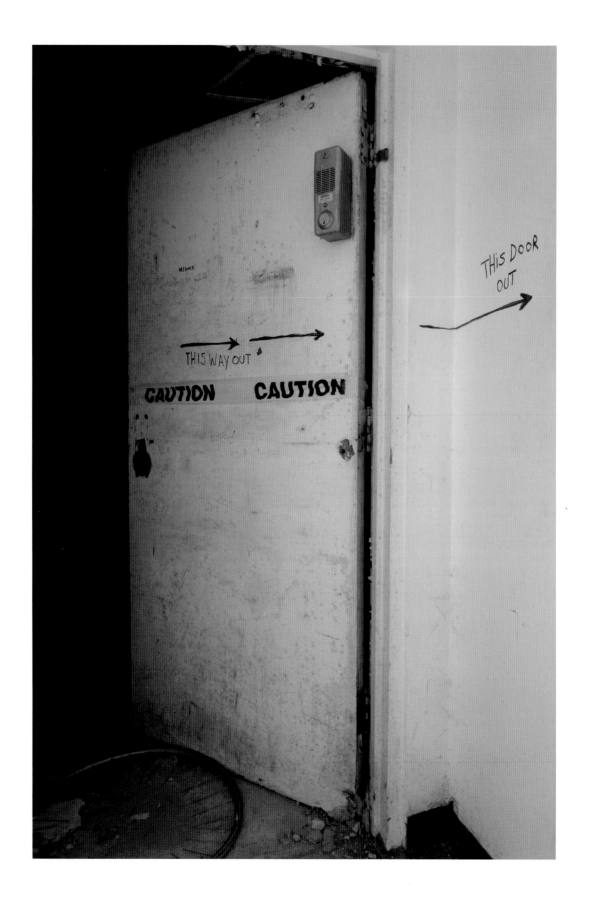

This Door Out—
Middleton Towers.

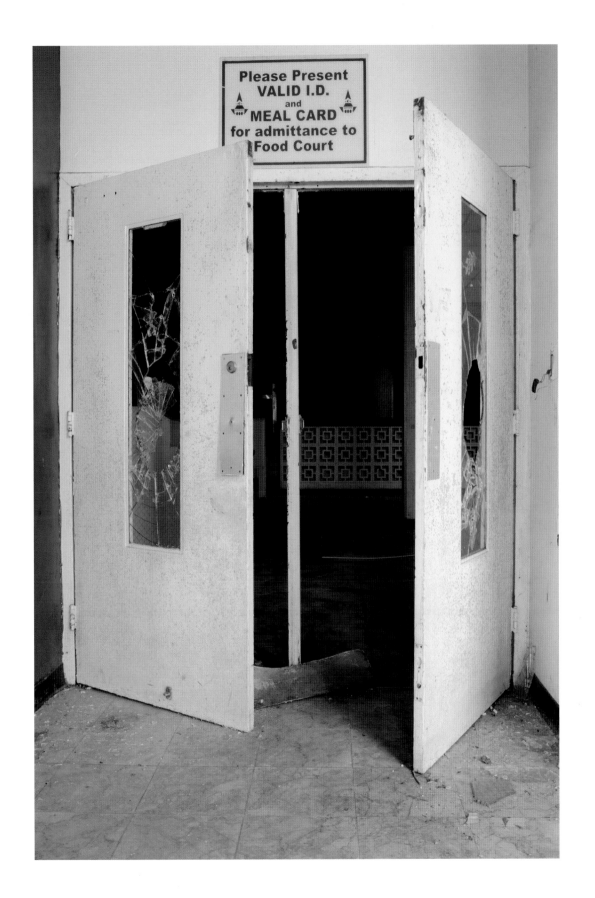

Food Court Entrance—

Middleton Towers.

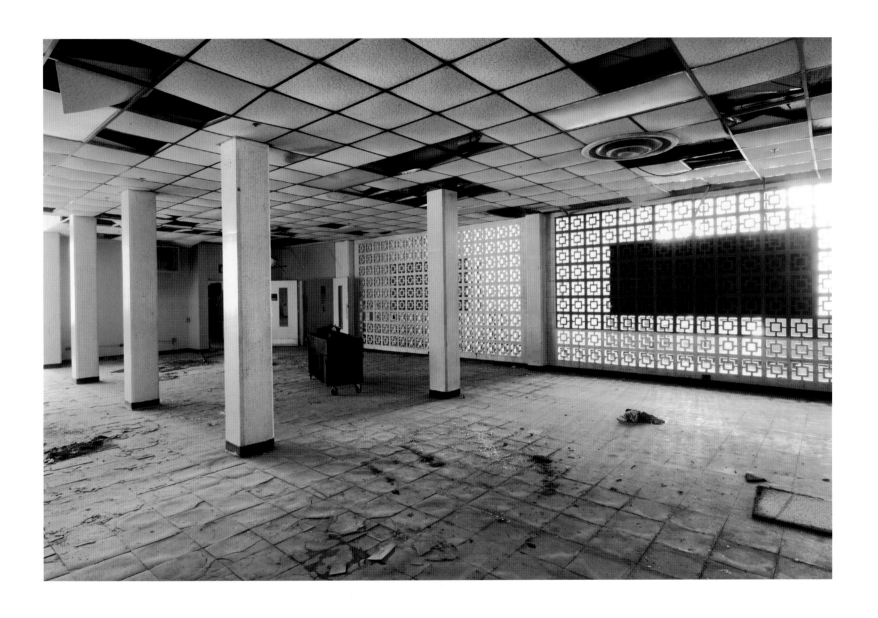

Food Court—Middleton Towers.

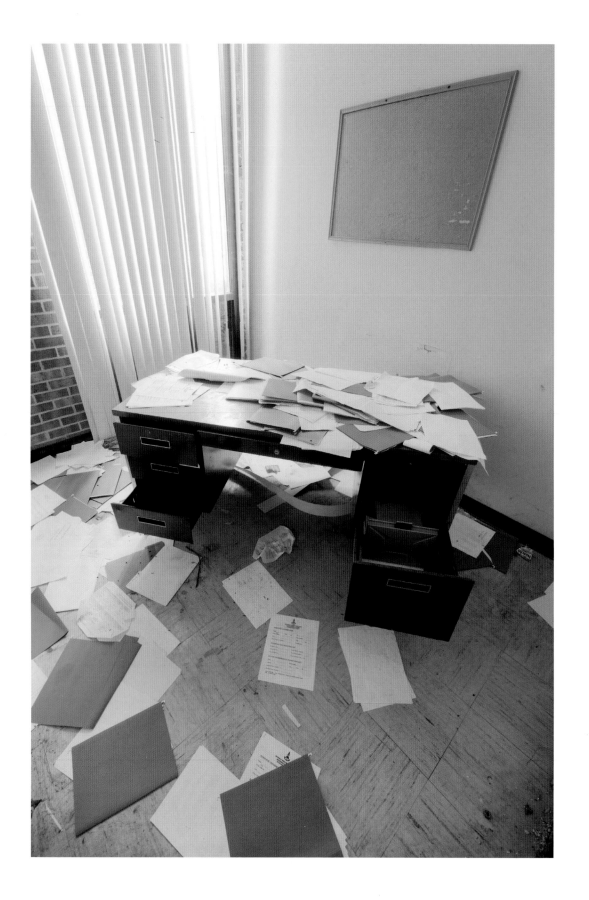

Files—Middleton Towers.

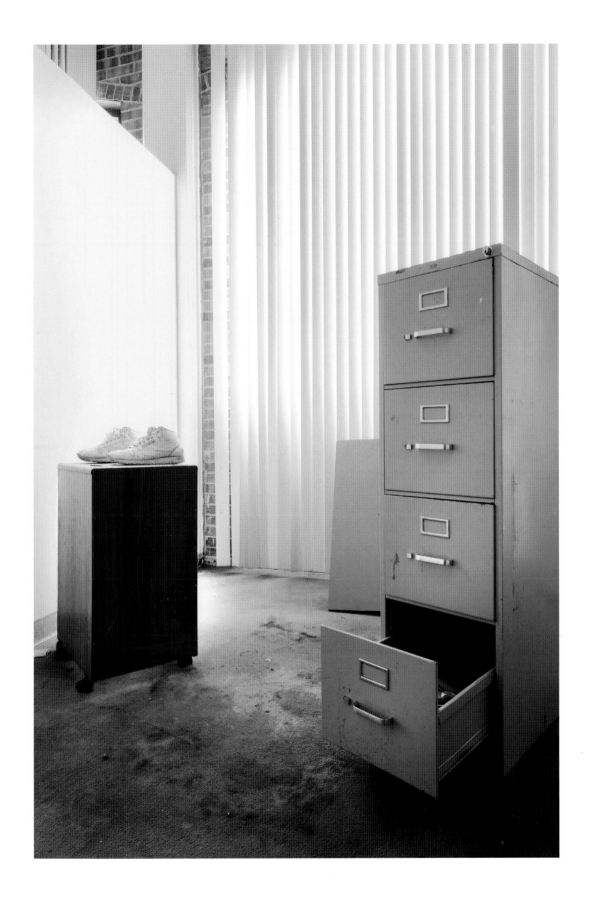

Homeless Hightops—
Middleton Towers.

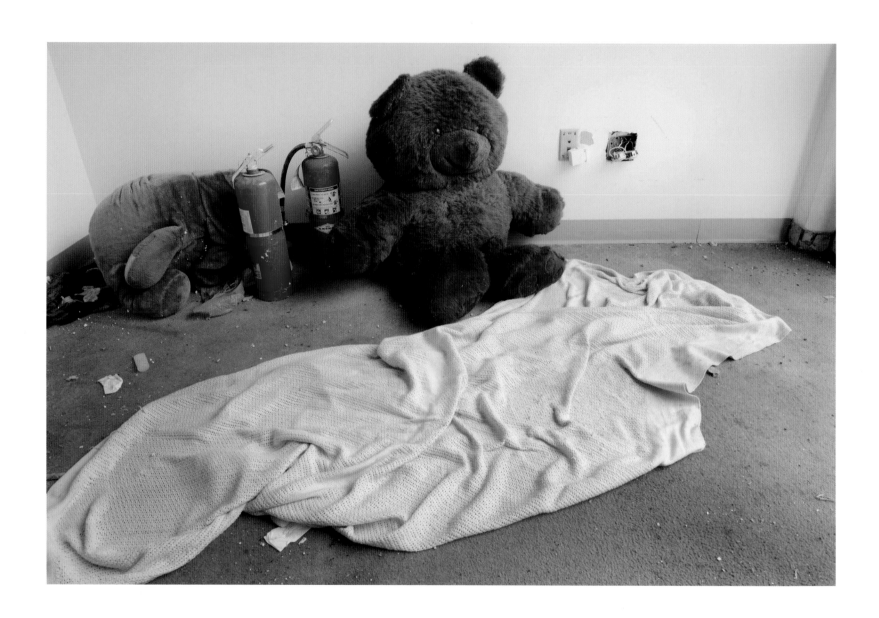

Bears and Fire Extinguishers—Middleton Towers.

Permanent/Flag—Middleton Towers.

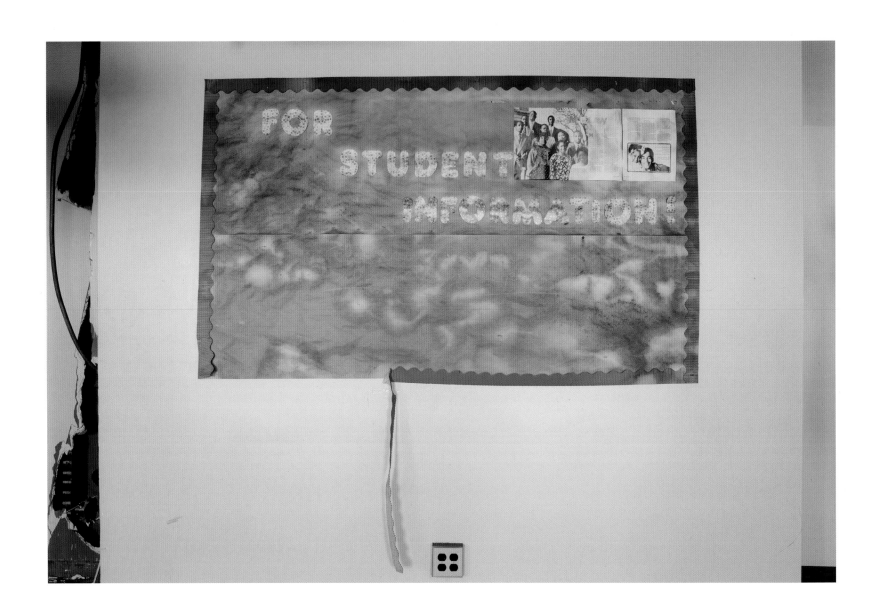

Bulletin Board—Furber Cottage.

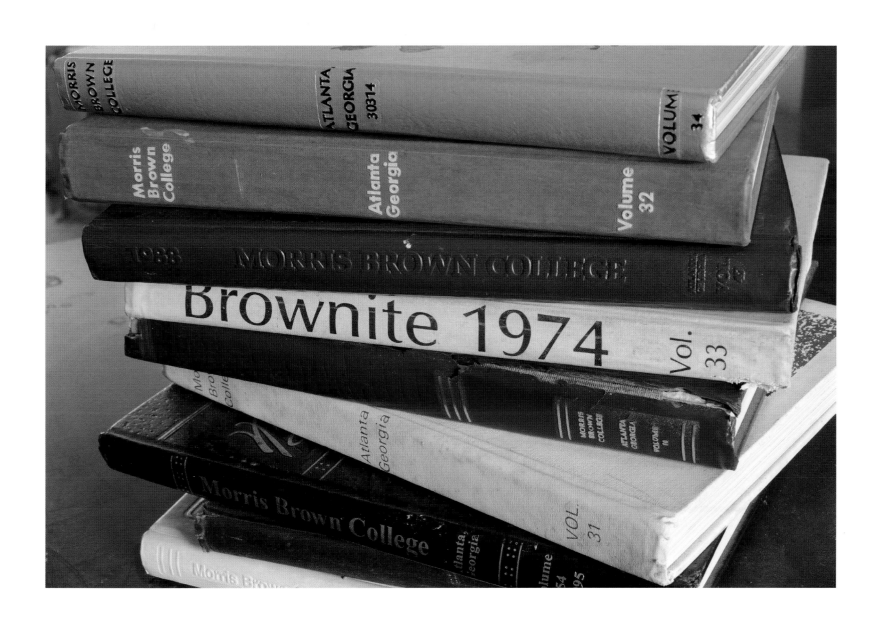

Yearbooks—President's Home.

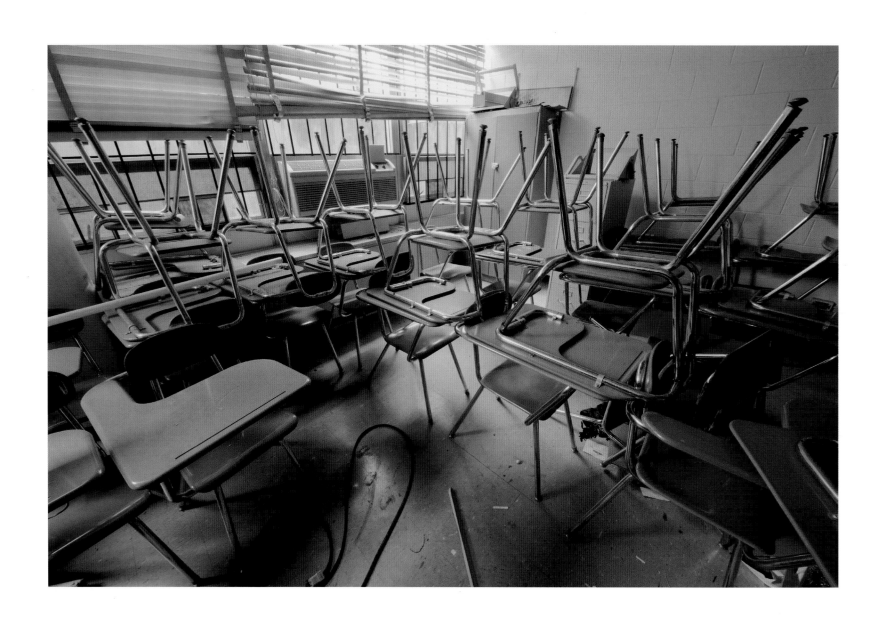

School Desk Jumble I—Griffin Hightower Center.

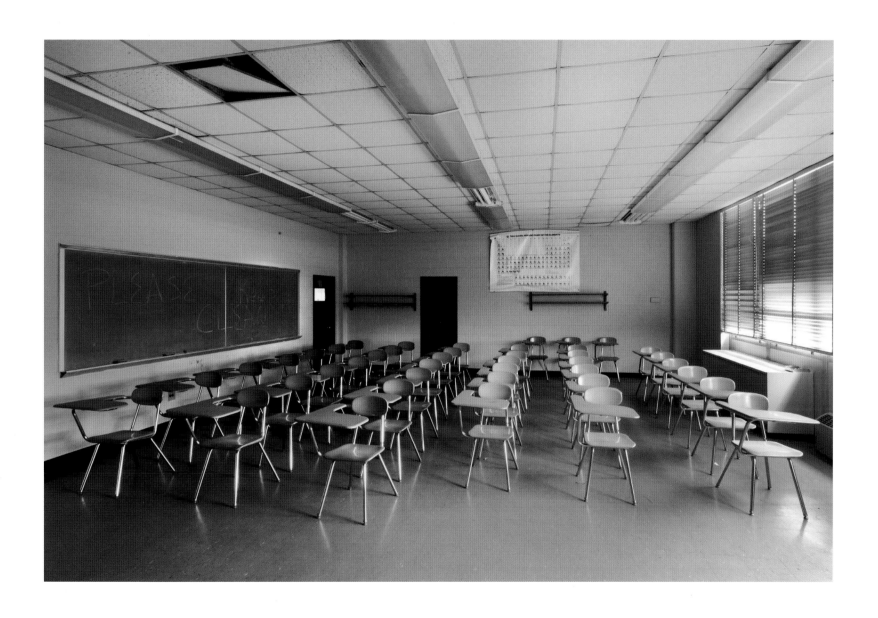

School Desk Array I—Griffin Hightower Center.

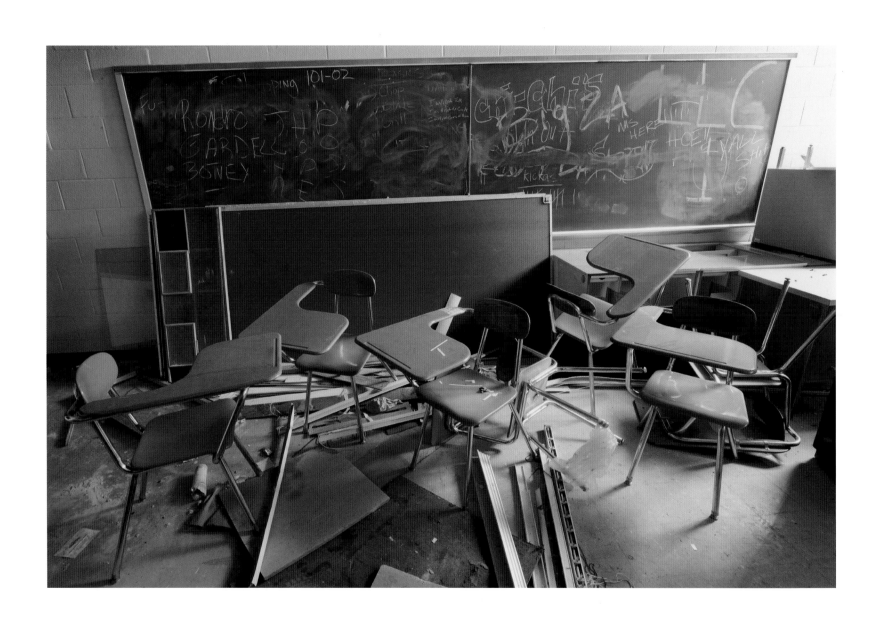

School Desk Jumble II—Griffin Hightower Center.

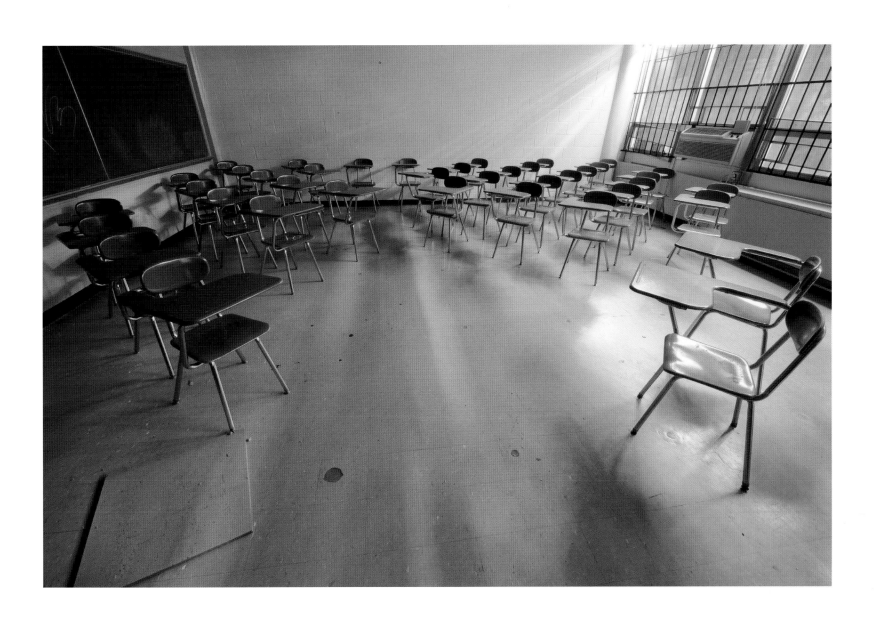

School Desk Array II—Griffin Hightower Center.

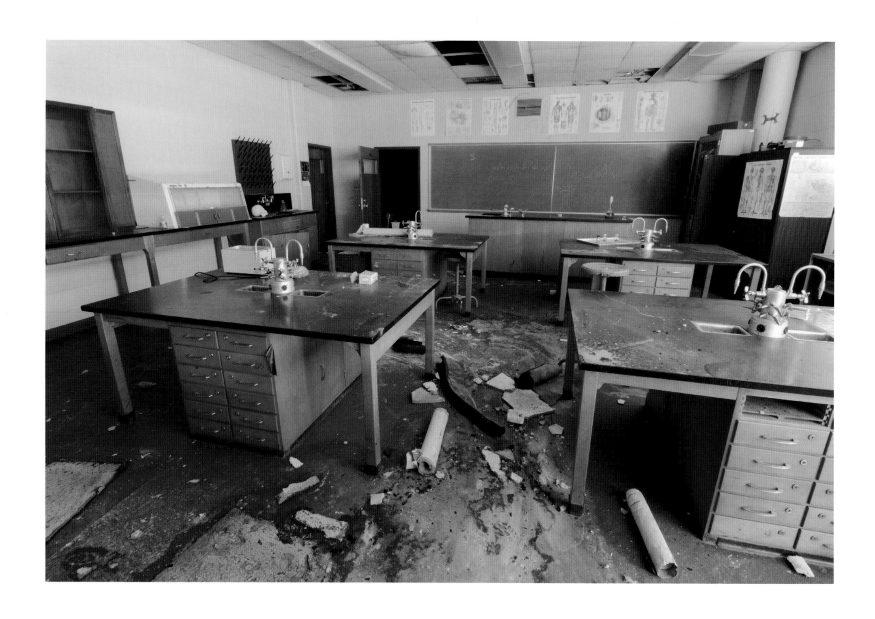

Science Lab—Griffin Hightower Center.

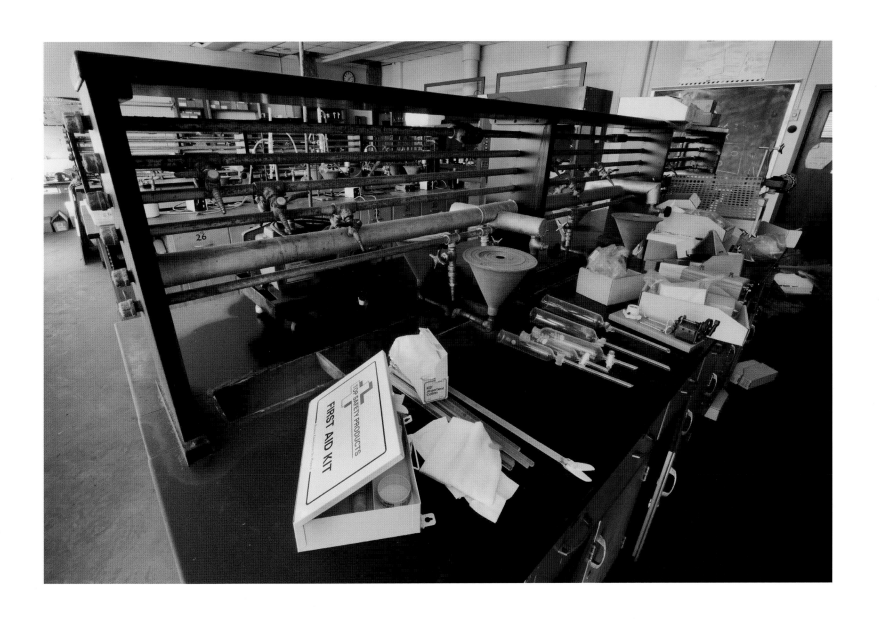

First Aid Kit—Griffin Hightower Center.

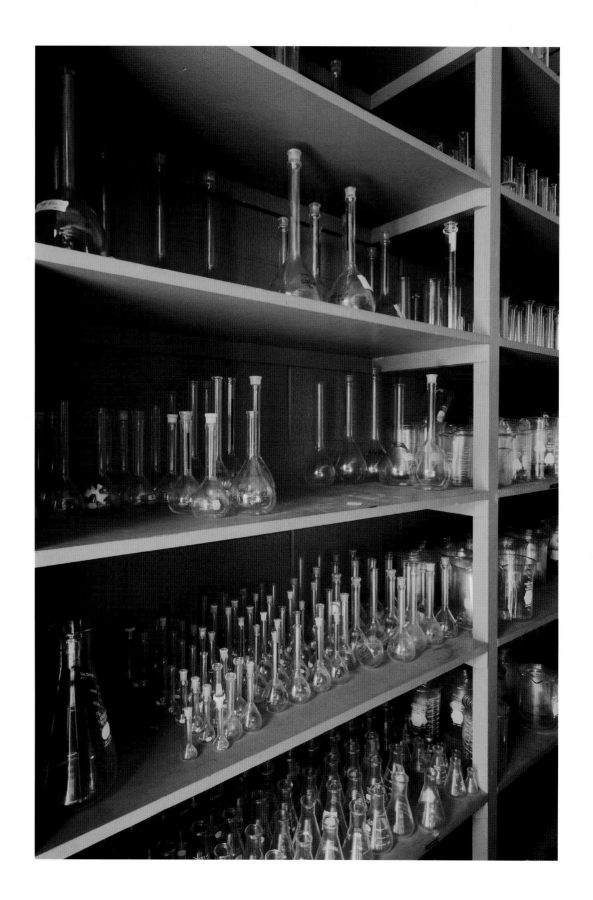

Beakers—

Griffin Hightower Center.

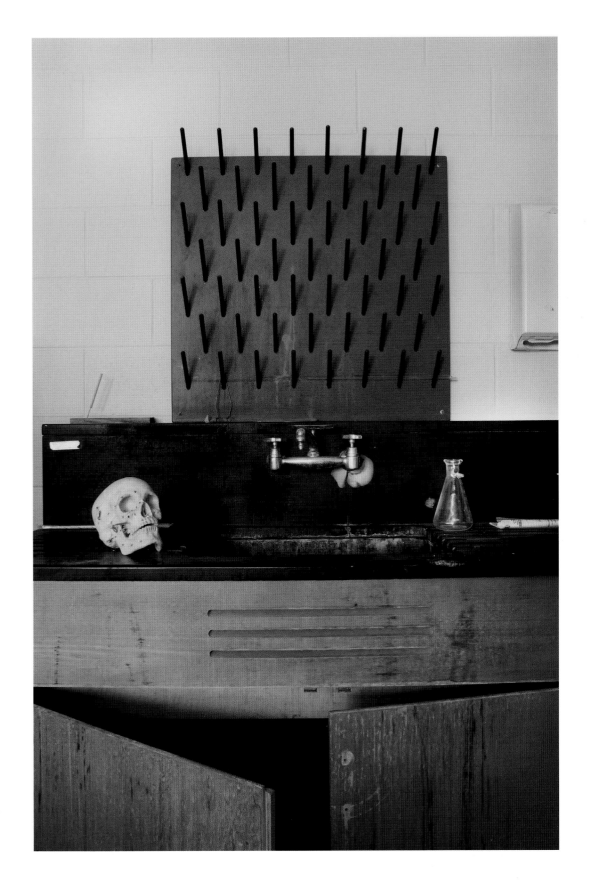

Skull and Sink—
Griffin Hightower Center.

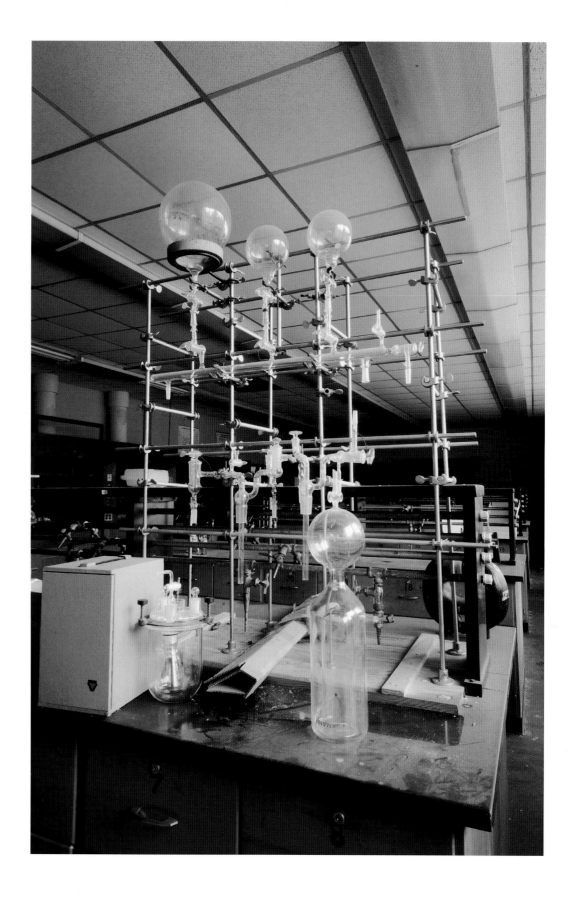

Science Experiment—
Griffin Hightower Center.

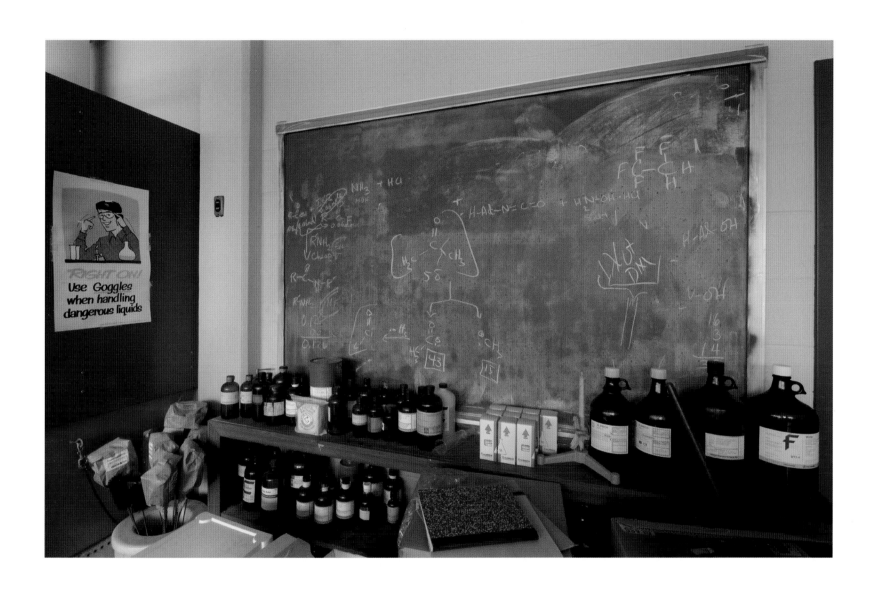

Use Goggles—Griffin Hightower Center.

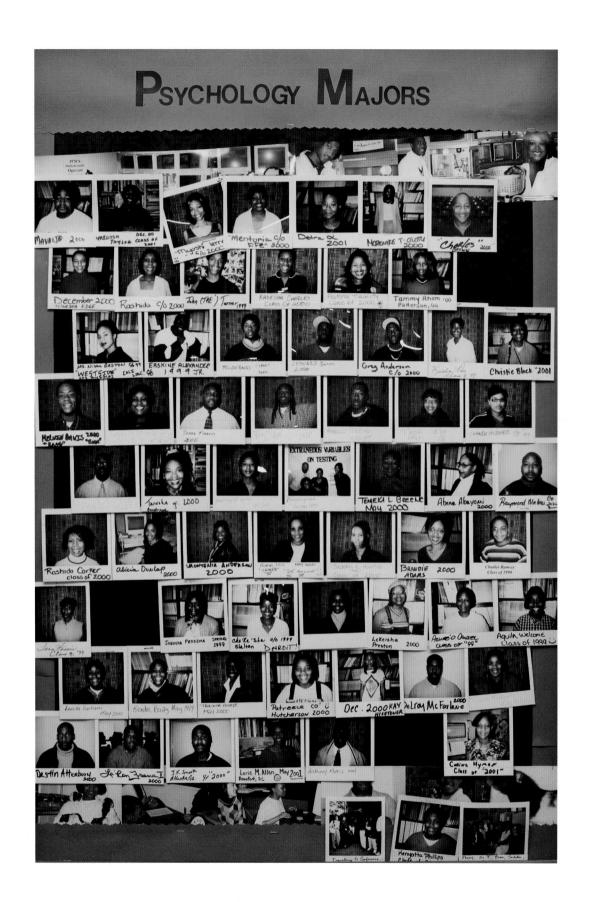

Psychology Majors—
Griffin Hightower Center.

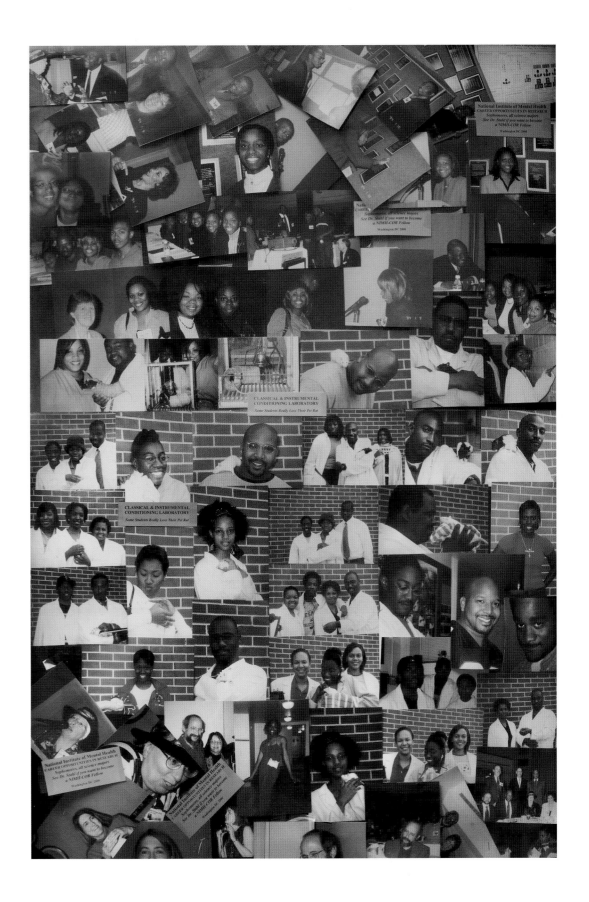

Pet Rats—

Griffin Hightower Center.

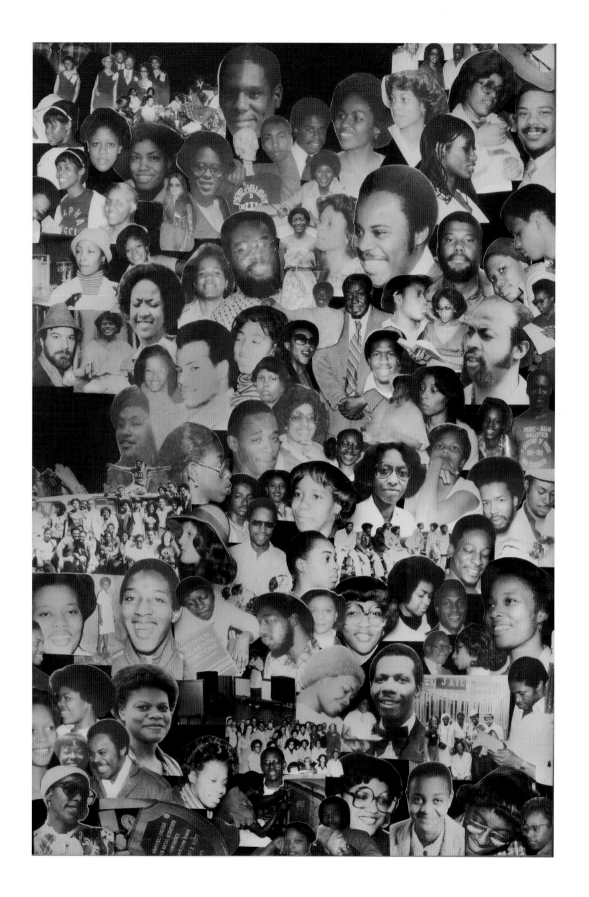

Campus Life—

Griffin Hightower Center.

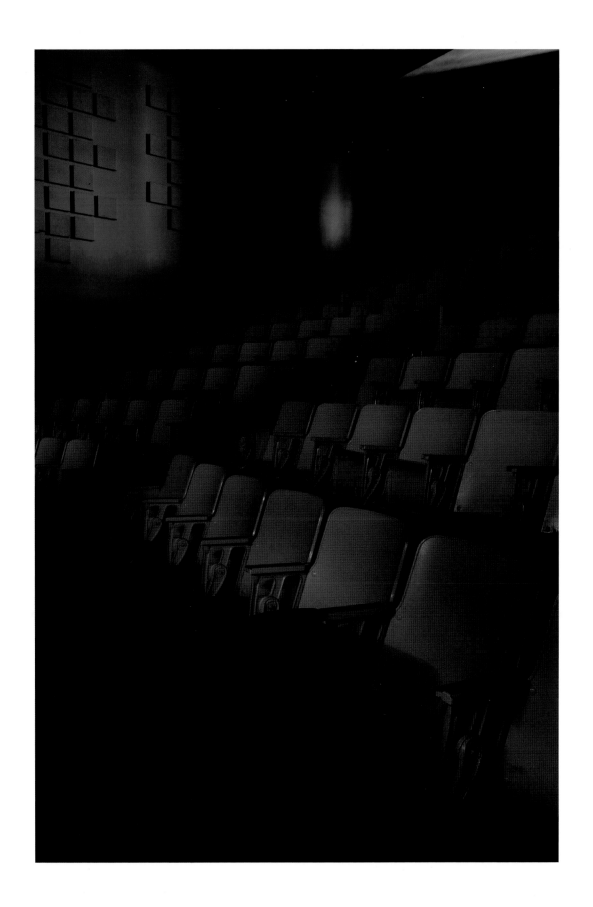

Auditorium—

Griffin Hightower Center.

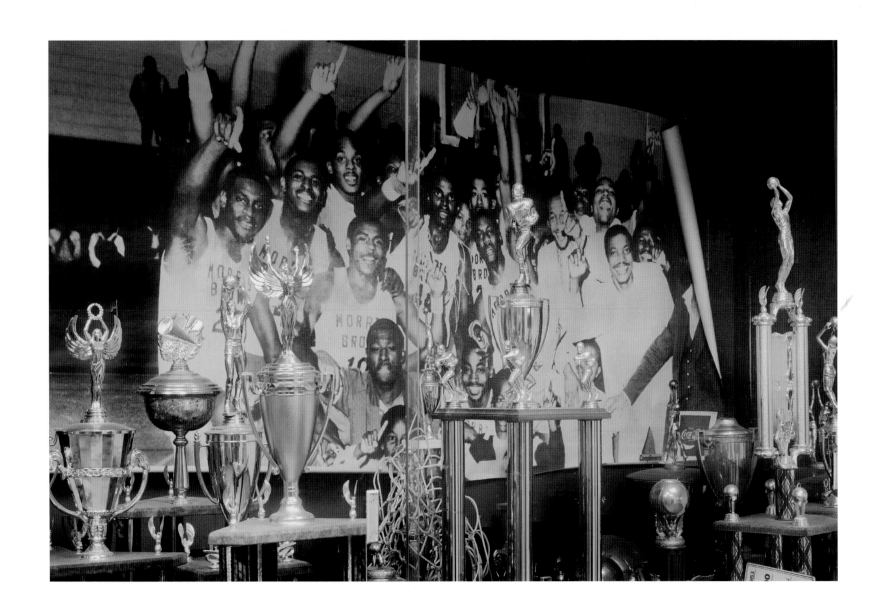

Trophies—John H. Lewis Complex.

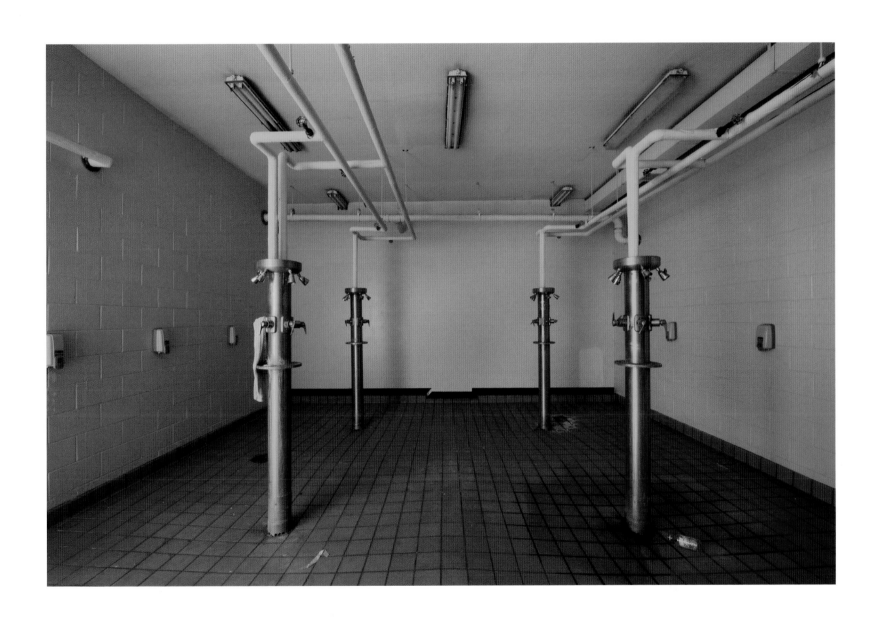

Showers—John H. Lewis Complex.

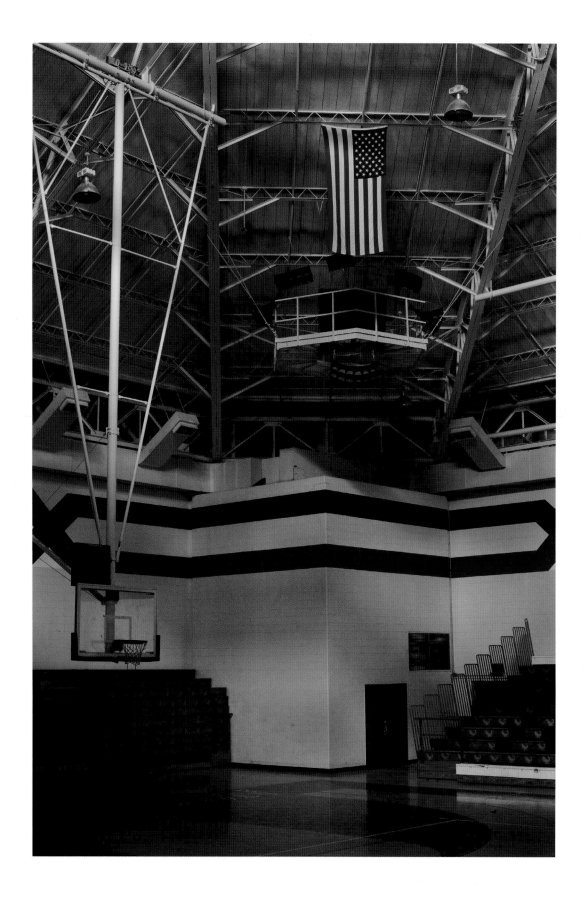

Flag and Basketball Goal—
John H. Lewis Complex.

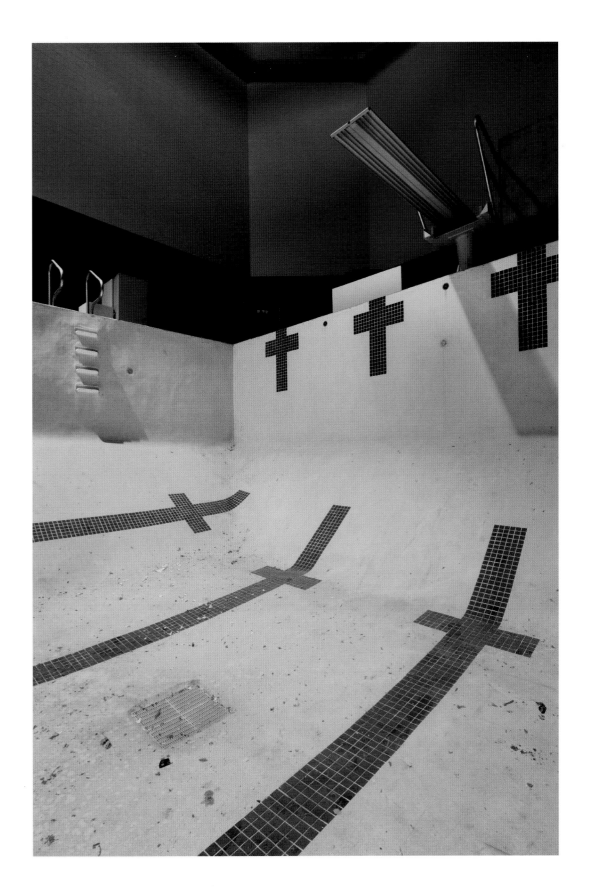

Diving Board—
John H. Lewis Complex.

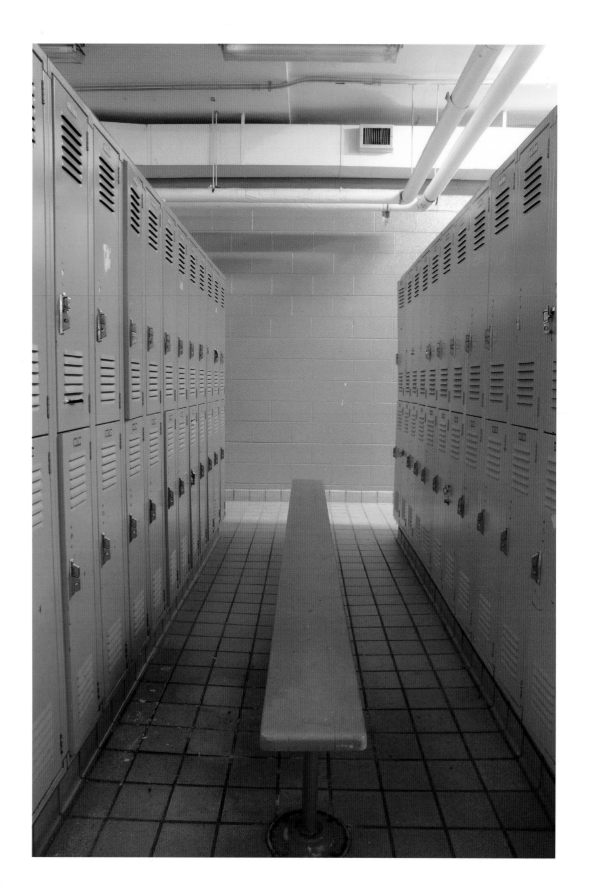

Locker Room—
John H. Lewis Complex.

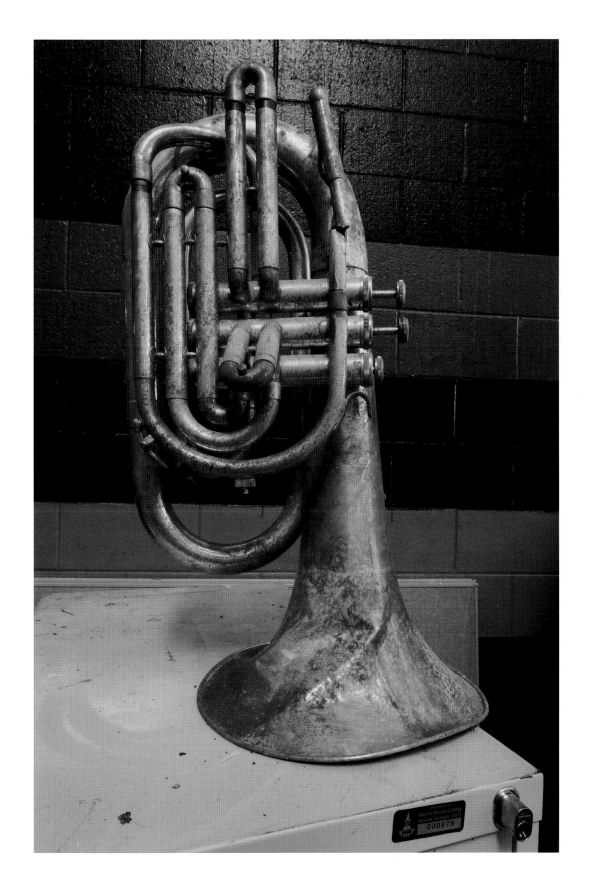

Marching Band Horn—
John H. Lewis Complex.

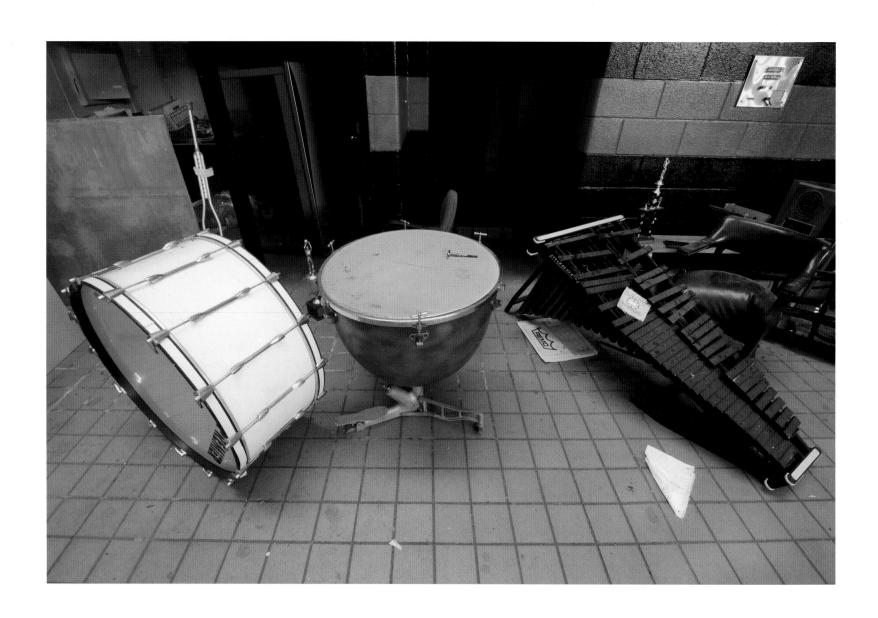

Marching Band Instruments—John H. Lewis Complex.

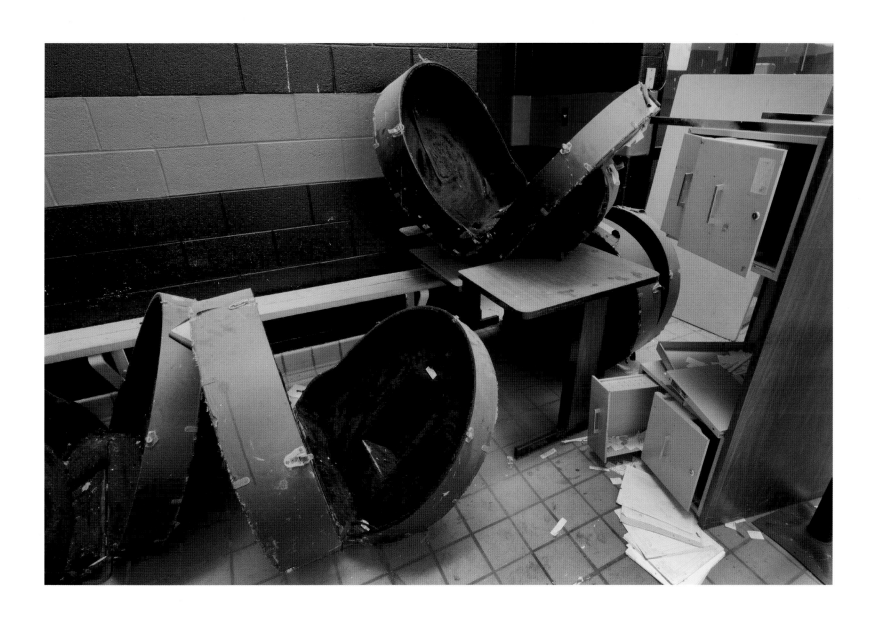

Marching Band Sousaphone Cases—John H. Lewis Complex.

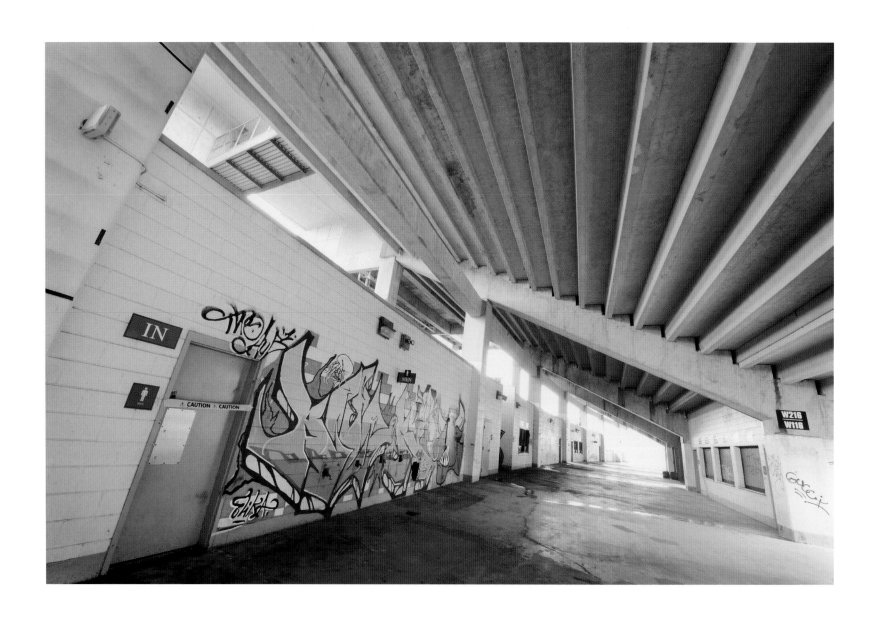

Under the Stands—Alonzo F. Herndon Stadium.

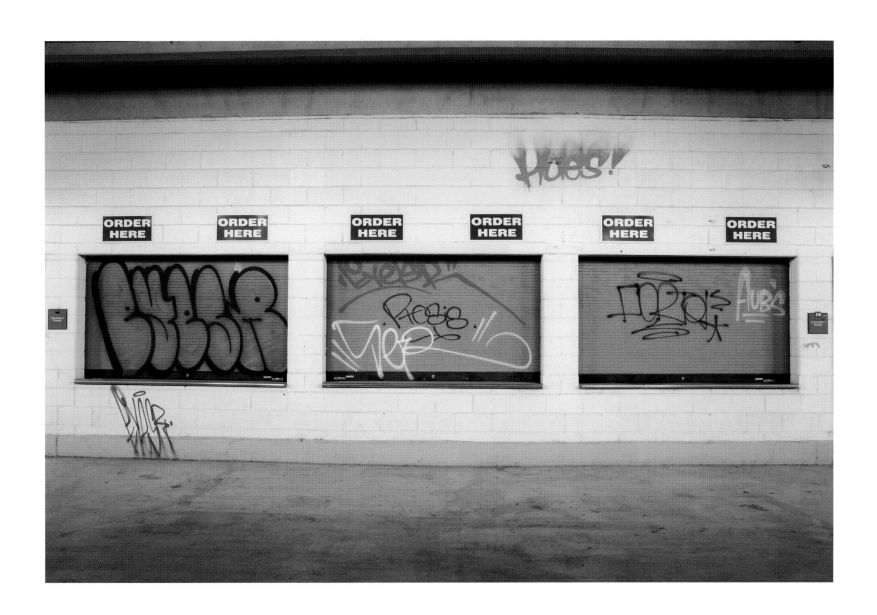

Order Here—Alonzo F. Herndon Stadium.

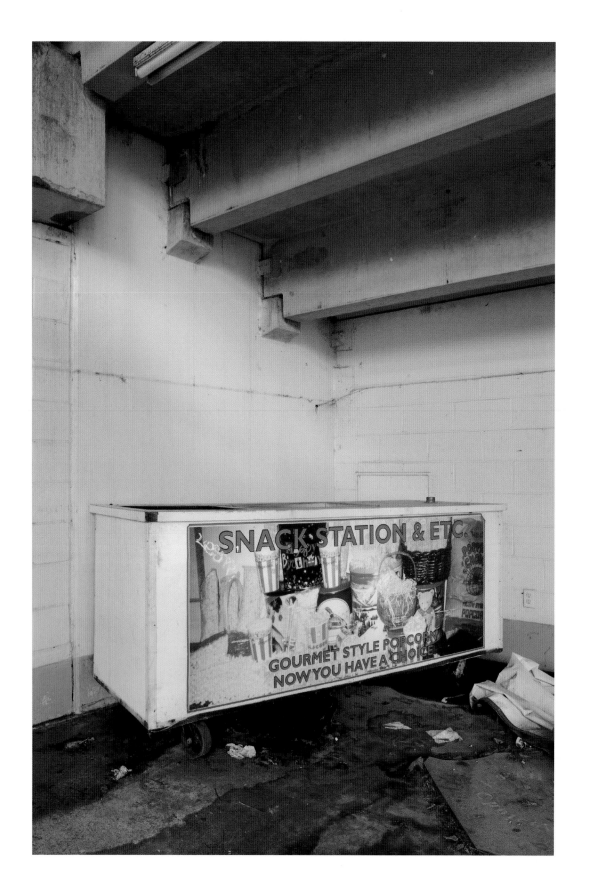

Snack Station & Etc.—

Alonzo F. Herndon Stadium.

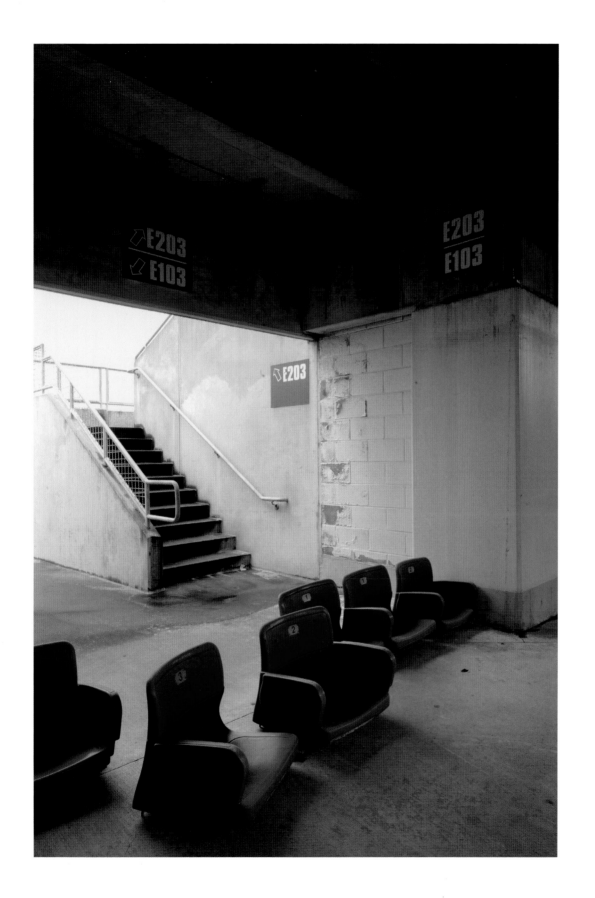

Reserved Seats—
Alonzo F. Herndon Stadium.

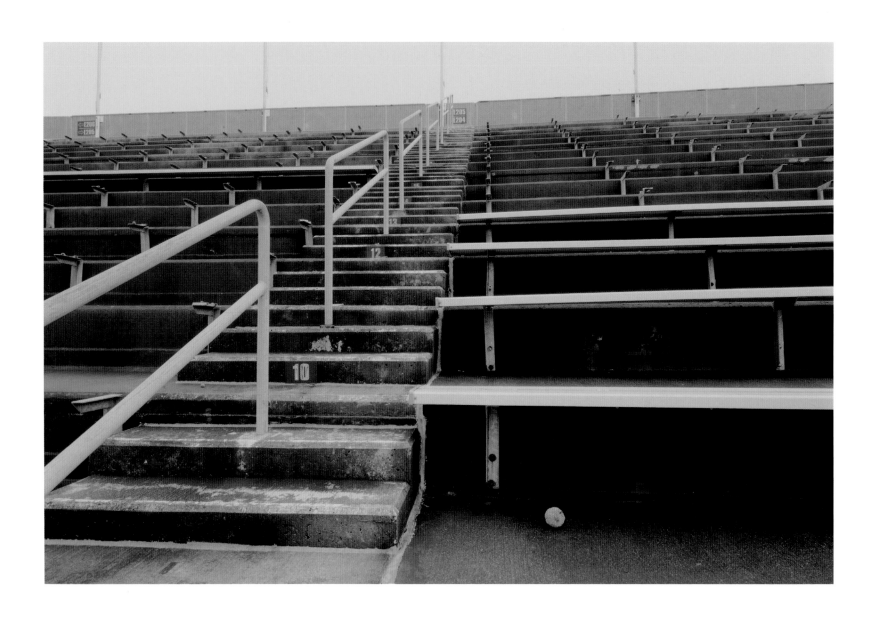

Stolen Seats—Alonzo F. Herndon Stadium.

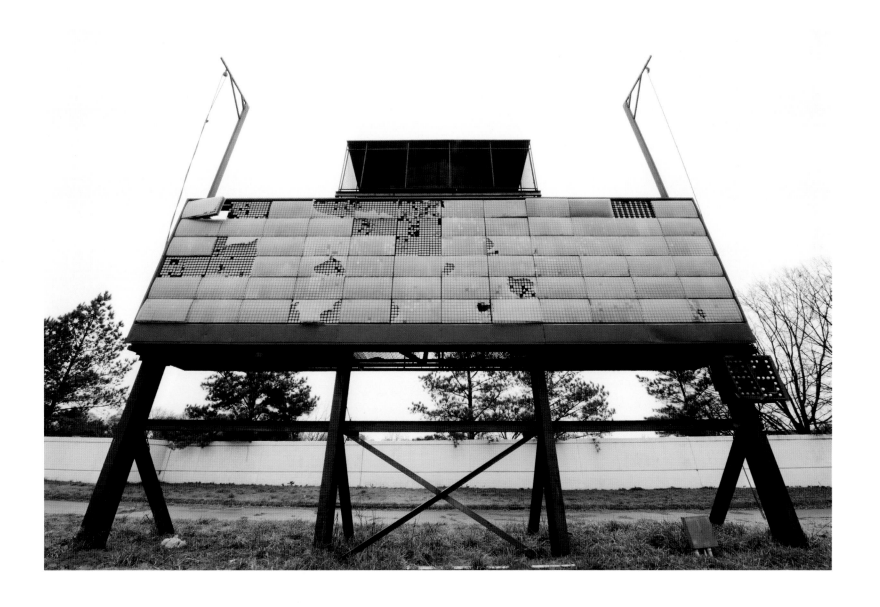

Scoreboard—Alonzo F. Herndon Stadium.

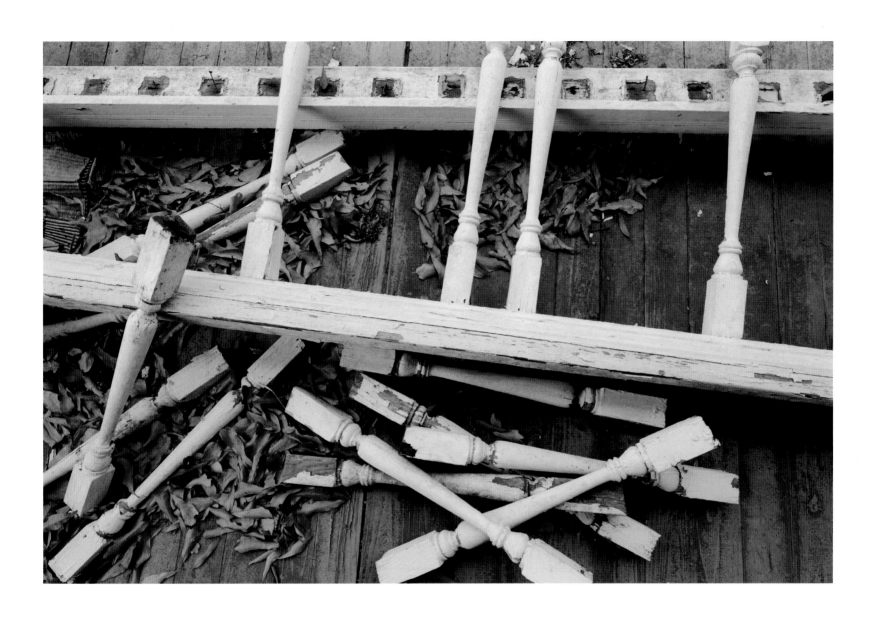

Balustrade—Alumni House.

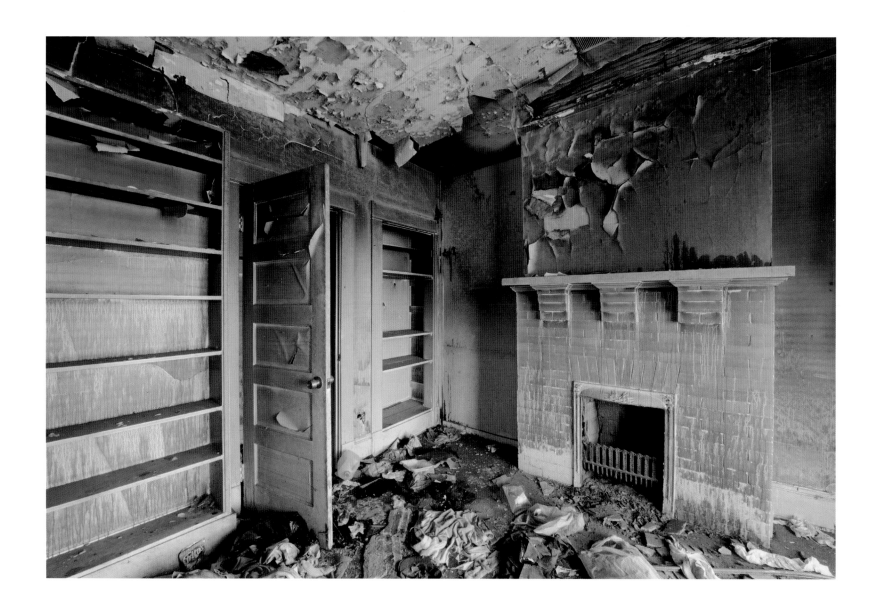

Fire Damage—Alumni House.

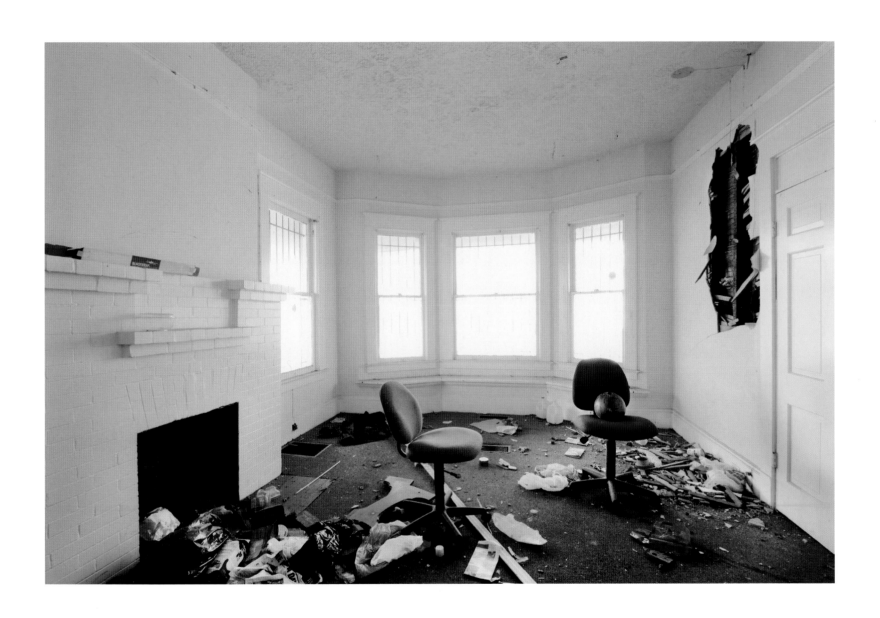

Bowling Ball—Alumni House.

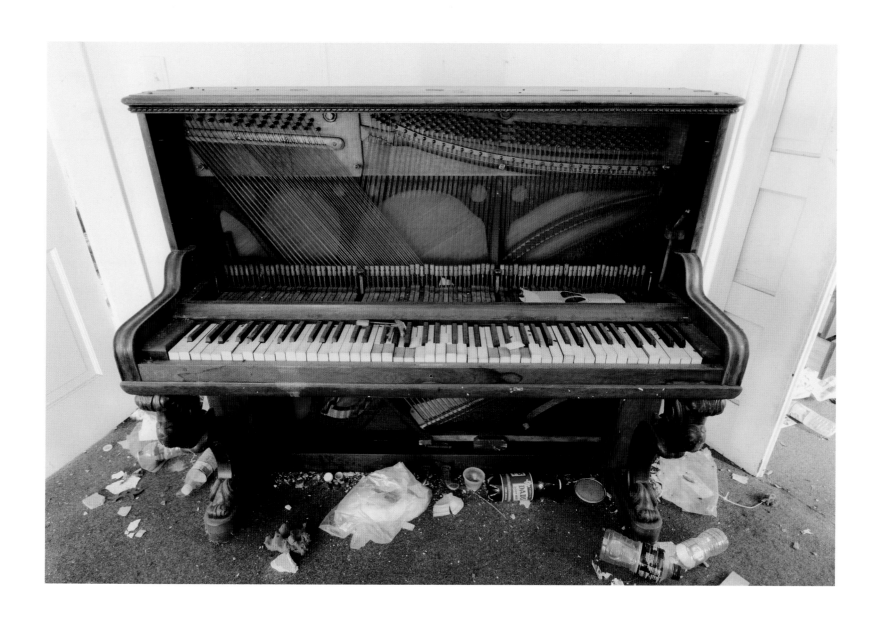

Piano—Alumni House.

A Matter of Relevance

History, Memory, and the Future of Historically Black Colleges and Universities

Collective memory is . . . an instrument and an objective of power.—JACQUES LE GOFF, 1977

Where memory crystallizes and secretes itself at a particular historical moment, a turning point where consciousness of a break with the past is bound up with the sense that memory has been torn—but torn in such a way as to pose the problem of the embodiment of memory in certain sites where a sense of historical continuity persists.—PIERRE NORA, 1994

Pellom McDaniels III

Andrew Feiler's project *Without Regard to Sex, Race, or Color,* a series of photographs of Morris Brown College, can be viewed as a collection of creative representations or "documentary fictions"[1] of what poet Amiri Baraka identifies as the "changing same" related to the social, political, and economic advancement of black people in America.[2] The history and memory of race and racism in the South, the value of community, and the critical importance of education for African Americans are embedded as the metanarrative throughout the series. Arresting, irrefutable, and rich, Feiler's photographs mirror the reality of the here and now, not only for Morris Brown but for a majority of historically black colleges and universities (HBCUs) attempting to protect the dreams of freedom, equality, and opportunity for a people still struggling to claim their birthright. These works articulate both the literal and figurative fragments left behind after Morris Brown was largely shut down in the face of challenging circumstances that led to losing the support of the federal government, city of Atlanta officials, and community leaders. The images also account for the appropriation of the space by transient inhabitants attempting to secure shelter and a sense of rootedness. This reality is not so dissimilar to thousands of students attending Morris Brown over the course of its history, during which it provided college access to the children of families often with lesser means and those seeking to affirm their identities as black people. Feiler's work as an artist and community servant provides a critical vision of Morris Brown College's past, present, and future through compelling images such as the *Centennial Mural* in Fountain Hall.

At first glance, Feiler's photograph of the *Centennial Mural* is a simple color likeness of Lee Ransaw's work commemorating Morris Brown's 1981 centennial.

Ransaw's mural represents the history of the college and its mission to educate, as well as to advance African American youth to achieve a sense of purpose through moral training and a rudimentary education. The portion of the mural in Feiler's photograph depicts historic Fountain Hall at its center. It depicts some of the African Methodist Episcopal (AME) Church leadership seminal in the history of the college, the extracurricular activities provided on the campus for the student body, and images of race heroes of the past to inspire African American men and women to pursue life to the fullest extent possible with a responsibility to their community. However, a closer reading of Feiler's photographic representation reveals much more. At the base of the mural on the left Ransaw depicts Steward Wylie, a layman attending the conference at which the college was founded. Wylie's speech famously led to the conference's commitment to create the school. "Mr. Chairman," he asked, "if we can furnish a room at Clark University, why can't we build a school ourselves?" Opposite of Wylie is an image of William Wilkes, bishop of the AME Church and chairman of the board of Morris Brown College from 1956 to 1964.

To the left and right of Fountain Hall, and illustrated in the school's colors of purple and black, are the pride of the Morris Brown Wolverine student body: a striding drum major and a leather-helmeted football player. In the early part of the twentieth century, the Wolverines dominated their rivals in the Colored Intercollegiate Athletic Association, especially the local competition in Atlanta. At the very top of the photograph on either side of the clock tower are depictions of Dr. Ann S. Cochran and Joe Louis Barrow. Cochran, a central figure in the history of the institution, was responsible for building the Normal Department to develop teachers who would educate African American youth. Joe Louis Barrow, better known simply as Joe Louis, was the heavyweight boxing champion of the world. While seemingly out of place, the image of Louis, who never attended Morris Brown, is an important inspiration for those of meager beginnings and limited opportunities to rise up from their circumstances and become someone. Louis made his greatest impact on school-aged African American children and young adults during his reign as heavyweight champion. He was the hero of the little people and made them feel big.

More than anything, the near closure of Morris Brown represents the reality of the ongoing assault on one of the most vulnerable populations of Americans: impoverished African American children. For African Americans, the opportunity to attend college is not only a right and privilege, it is also necessary in an increasingly competitive global society unforgiving of those without advanced degrees. Feiler's

lens captures what on the surface appear to be abandoned buildings, facilities, and former living spaces of hopeful individuals, now void of life and the activities central to institutions for higher education. The bare walls and empty classrooms provide traces of what *was*, while resonating with a powerful reminder of what still *can be*.

Feiler accounts for the current historical moment in education for African Americans, the legacy and future of Morris Brown College, and the charge for HBCUs in general. While education remains central to an ever-advancing society, for African Americans in particular, gaining access to quality, school-based curricula in twenty-first-century technologies; training in the most relevant fields of science, engineering, and public policy; and strengthening the urban core where a majority of African American families reside are central to ensuring that future possibilities are attainable. Based on his understanding of "history and culture, geography and race, tradition and conflict, injustice and progress," Feiler has trained his head and his heart to see, compose, and execute his aesthetic through the medium of photography. Images of classrooms on the Morris Brown College campus with desks neatly arranged and ready for students to engage in the learning process; a shot of student mailboxes—some still closed and locked, but all empty; a stack of "Brownite" yearbooks on a table top; and an image of an office with mismatched furniture, a clear indication that the institution was working with what was available to serve its students' dreams for a better life, all provide a grounded artistic interpretation of a historical event unfolding as both a part of and apart from the recorded narratives related to the future of HBCUs. Moreover, tied to the historical record and the individual and communal memories associated with Morris Brown College is an opportunity to understand the intended and unintended consequences of Feiler's choices. This provides a way of seeing the photographs as "documentary fictions" that can guide future decision making by Morris Brown College officials.

Feiler's project also provides a backdrop for a dialogue about the unmitigated erosion of public education for African Americans and its consequences on their quality of life, compounded by a future that portends the renewal of past grievances once believed to have been settled by *Brown v. Board of Education of Topeka* and civil rights legislation. While the notion of a "postracial society" continues to energize the Right and to excuse efforts to derail support for America's future growth through universal health care, access for all to a quality education, and the right not to fear the people who are sworn to protect you, the reality is that black and brown people are still incarcerated at higher rates than whites for similar infractions.

Crime rates in communities of color are not caused by some imagined inherent pathology in black people but are the result of poverty, lack of education, and a sense of hopelessness that creates a predatory environment where nothing is sacred. The corporeal and psychological aspects of everyday life are integral to our embedding these historical moments and making sense of them in accessible ways that help to maintain a greater sense of community while engendering an increased capacity to move people to action for the benefit of the group.

In *Without Regard to Sex, Race, or Color*, Feiler's photographs function as a *tableau* of a critical site of memory for African Americans—a guidepost, if you will, to mark time, access the past and present, chart a new course for the future still unwritten, and continue the journey with a renewed sense of purpose. But what happens when a faithful people of long memory begin to forget their past and the value of their core sources of power, their ancestors? What is the cost of losing one's understanding of history and the choices made by those long past? The father of black history, Dr. Carter G. Woodson, argued that "if you are unable to demonstrate to the world that you have this record, the world will say to you, 'You are not worthy to enjoy the blessings of democracy or anything else.' They will say to you, 'Who are you anyway?'"[3] For African Americans, this is not so much a choice consciously made as it is an outcome of not maintaining a firm hold on the past; of not understanding the many challenges and successes that have affected the community as a whole; and of refusing to jealously teach the African American community and its children lessons from the past that helped maintain hope against despair for a tormented people whose eyes always remained fixed on liberation and freedom.

For African Americans, history and memory are two very distinct but dependent ways of recalling a shared past. On the one hand, the written record and material artifacts of the unfolding of historical moments document their development and the impact of choices made locally (in communities), nationally (from coast to coast), and globally (the African Diaspora). Being connected to a historical record allows individuals and communities to claim a station in the world from which they can move confidently within the global marketplace. Documents, photographs, and correspondence provide the proofs needed to support claims of citizenship, manhood, and womanhood. Similarly, the individual and communal, or collective, memories of past events are interwoven with everyday sounds, smells, textures, and emotions, which are powerful reminders of one's inheritance. The music we listen to, the foods we eat, and the way we hold our bodies in space are emblematic of how we

see ourselves in the world, but they also indicate how we want to be acknowledged. Who we are as black people is not so much determined by what has been recorded as history. Who we are as black people is felt as both a lived experience and a shared reality of the history that has preceded us and the present that is constantly unfolding around us. Morris Brown College and HBCUs are still needed as sources of pride and inspiration for African Americans, especially the community's youth who have in front of them a world filled with endless possibilities, amidst the turmoil created by recalcitrant white Americans working hard to deny black Americans access to the resources needed to succeed.

Discursive Narrative

Deserted Spaces, Dubious Times

Amalia K. Amaki

Hail to Thee, maker of men,
Honor to Thee once again,
Sacred truths on firmist ground,
Hail to Thee, Dear Morris Brown.

As these almost muted lyrics from the Morris Brown College hymn extol the institution's virtuous past and speak with prophetic irony to its sobering present and challenging future, photographer Andrew Feiler makes pilgrimages through quiet, abandoned campus structures documenting their desolate interiors and seeking whatever redeeming qualities may be found. [1] The resulting visual narrative, *Without Regard to Sex, Race, or Color: The Past, Present, and Future of One Historically Black College*, portrays the architectural deterioration on the grounds of the first African American independently owned and operated higher education institution in the state of Georgia. A member of the Atlanta University Center until released in 2002, Morris Brown served a distinct purpose in the largest consortium of African American colleges and universities in the world. With a small section of the college still in use, Feiler's photographs underscore the blunt physical reality threatening the school's remaining visibility and viability, revealing areas once energized with sights and sounds of academic pursuits as silent, uninhabited spaces with ghostlike reminders of prior functions; places originally intended for human occupation as harbors for fallen plaster, dust, and debris; and objects previously associated with effective study as being left behind, commingled with other items trashed during speedy exits.

The photographs in *Without Regard to Sex, Race, or Color* speak for themselves with clarity, candor, and meaningful associative impact. Broken windows, busted furniture, trashed offices, dulled band rooms, and dismantled classrooms tell their individual stories via content and character without need of further elaboration, but they speak virtual volumes as correspondents to the shattered hopes, dreams, and

aspirations of the people who were and are emotionally invested in Morris Brown and all that its legacy represents.

Within the context of photography as a medium of expression and historical placement, *Without Regard to Sex, Race, or Color* joins other significant volumes of contemporary architectural landscape photography of abandoned spaces. The highly personal, iconic work by Stephen Wilkes on the hospitals of Ellis Island (1999–2003), gut-wrenching exposés of mental asylums at state facilities by Christopher Payne (2009), and the straightforward portraits of abandoned Detroit told through deteriorating interiors by Andrew Moore (2010) come first to mind. Feiler's work is a new addition, bringing to the forefront a graphic awareness of the immediacy of the educational crisis facing Morris Brown especially and the nation generally. Wilkes, Payne, and Moore offer poignant visual accounts of the aftermath of systematic neglect, desertion, and displacement, making their points in images that waver between sadness, horror, amazement, intrigue, grief, and disbelief. Select works are captivating in their beauty alone. Others, despite being raw depictions, are attractive in large part because of their frankness. Feiler homes in on violations of trust and deferred dreams of a different sort. The psychological clocking out and blatant omission uncovered in the world of his photographs tap into some of the same root issues explored in his contemporaries' images, holding up a mirror at a different stop along the same bus route, so to speak. Yet they are distinct in their terms of the nature of disregard and inhumanity shrouded in the metaphor "Morris Brown." They, too, possess some haunting appeal, but their association with beauty is as codified as the circumstances facilitating their existence.

Another shared quality in the work of Feiler, Wilkes, Moore, and Payne—along with such figures as Susan Dobson, Matthew Christopher, Jeff Brouws, and other similarly inclined landscape photographers—is the time element. Dobson (*Sense of Ending*, 2013) emphasizes that the ability to dislocate from definitive time ignited her interest in photography.[2] The perceived convergence of space and time in the work of these photographers—a fusion of past present future—renders these dimensions as sensations more than relevant demarcations. Concepts of past, present, and future are mysteriously inseparable in these images. There is a coexistence with the remains, leftovers, trash, and discards. The landscapes not only stand in relative present conditions represented in the photographs, they are also continued (other) forms of their prior selves—forms inseparable from the human purpose of their origin, the artifacts/remnants humans left behind, and indivisible from man's contemplative

response or prospective use. Through reflection—actual and imagined—visits to abandoned spaces in truth (in person) or via trust (by viewing photographs) are essentially journeys through timelessness—looking out, looking backward, looking forward with simultaneous perception where neither (time) orientation is dominant and no lines are drawn. Scientists Albert Einstein, Richard Feynman, and Stephen Hawking have advanced related complex ideas of the timelessness of the universe, with Einstein ultimately considering perceptions of a separation between past, present, and future to be "convincing illusion."[3] Writer Kurt Vonnegut succinctly stated: "Everything that ever has been always will be, and everything that ever will be always has been."[4]

Human presence is another core element of these photographers' works. Wilkes alluded to this connectivity in his discovery of the elusive property in his Ellis Island series, commenting on "an undeniable evidence of life in remembrances of people and in the radiant, beckoning light that infiltrated the scenes." Similar manifestations in Feiler's work emanate from various sources. The close-up of a photomontage of students' faces united in a shared field of study hangs intact and unmarred on the wall of a departmental wing. Blackboards covered with handwritten formulas and problem-solving steps in seemingly fresh white chalk remain undisturbed in orderly staged classrooms. Clean, sparkly bottles, test tubes, and other containers sit in meticulous rows on storage shelves in laboratories. A purple Teletubby (TinkyWinky) mysteriously appears between Feiler's visits, seated on the edge of a desk in the front of one classroom. In addition to being purple (one of Morris Brown's school colors), TinkyWinky is the oldest and largest Teletubby and has an antenna on his head.[5] In different areas, evidence of defacing, looting, and random acts of vandalism attest to another type of human presence. Each account contributes to the reality of the ever-morphing landscape. In concert with Feiler's fundamental community-based interests, *Without Regard to Sex, Race, or Color* invites inquiry into and conversation on the implications of the photographic genre it represents as well as the social, political, and educational questions raised by Morris Brown's dilemma.

Afterword

If we consider the number of HBCU's that have closed their doors in the past twenty or so years, and the number that today are struggling to make donors, accreditors, and governmental sources understand their value, we see a picture that is out of focus.

Within the covers of this book we have viewed pictures worth a thousand words meant to stimulate discussion. Andrew Feiler's photographic essay captures Morris Brown College, or at least some of what was and, sadly, of what is left of the historical Morris Brown College.

MBC was established in 1881 and opened its doors in 1885 with the creditable vision of providing an opportunity for people of color. Over the course of more than 120 years, the college enrolled tens of thousands of men and women and graduated thousands of them. The college has an honorable roster of alums who have accomplished a great deal in their fields of study and vocations of choice. It is important that we celebrate the accomplishments of this institution of higher education and opportunity, and that we commend the staff, faculties, and administrators who have carried honorably the responsibility for MBC's mission "to provide educational opportunities in a positive and nurturing environment that will enable its students to become fully functional persons in our global society . . . to live meaningful and rewarding lives, (and) to make socially constructive and culturally relevant contributions to society."

The walls, the windows, and the rooms that remain bear little witness to the past, and the remaining facade of Morris Brown College articulates a story of plunder, neglect, and vandalism—a story that rips at the heart strings of each and every one of us. Nevertheless it is a story that has to be shared. Photographers like Andrew Feiler, documentarians, humanities scholars, libraries, and archives are important participants in this storytelling. For they are committed to preserving the evidence and memories of old so that we can use them to influence future activities and decisions that are yet to be made. This is the basis of the humanities, and in the academy

Loretta Parham

these people form the building blocks of learning by providing crucial knowledge of our past.

As chair of the Georgia Humanities Council I have seen how the humanities have enriched the lives of men, women, and children in a variety of communities. With thoughtful discussion and reflection and the formation of institutional partnerships between libraries, universities, museums, and archives, we gain a greater understanding of our past and of how it can influence our future. We cannot hide or dwell in our past, and we cannot fear our future. Hopefully Andrew Feiler's photographs of abandoned places on its campus will contribute to a renewed vision for the hallowed ground of Morris Brown College.

So I encourage you to view the photography contained in this book many times over. Each exposure will provoke a new thought and reveal another nuance of light and darkness and, yes, offer focus.

We should appreciate Feiler's photographs, even if we do not appreciate how they make us feel. We must acknowledge that they offer a format for the study of humanity. They capture and immortalize the glorious past, and we will not forget it.

Looking forward, new walls may be built to capture new memories. We will have this essay, these images, and the contributions of the many women and men who still dedicate themselves to the "old Morris Brown spirit" without regard to sex, race, or color . . . still.

Acknowledgments

This project never would have started without the backing of Stanley Pritchett Sr., president of Morris Brown College. I remain deeply grateful for the trust, confidence, and support that he has offered throughout this endeavor.

For over a decade, Sonny Walker has been a friend and colleague, working in common cause to make our community better. A great activist in the best sense of that word, he serves as vice chairman of the Morris Brown College Board of Trustees. His support came before all others and was indispensable.

Loretta Parham, CEO of Atlanta University Center's Woodruff Library, was an early and enthusiastic supporter of this work, and her afterword is a thoughtful addition to this book's literary element. Lisa Bayer, director of the University of Georgia Press, has been an extraordinary partner in imagining and creating this publication. Jamil Zainaldin, president of the Georgia Humanities Council, was instrumental in envisioning the wider import of my work. Doug Shipman, founding CEO of the National Center for Civil and Human Rights, has been a great friend and provided sound counsel throughout. A special thank you to Julia Franks . . . exceptional teacher, gifted novelist, and for many years an incisive critic of my photography and my writing.

At the intersection of art and activism, the essays in this book have powerfully accentuated the stories surfaced in my photographs. Robert James, Pellom McDaniels III, and Amalia Amaki brought diverse experiences and points of view to this project, and their writings and their voices have enhanced this book. Allen Gee and Rachel McPherson also offered warm support of this publication.

During the year that I spent on Morris Brown's campus in classrooms, labs, locker rooms, and more, my security team was professional and patient. Thank you to Ahmed Bryant, Rossio Carter, Maurice Johnson, and Jamar Thompson.

I have been blessed by an array of friends, colleagues, and mentors in photography. The late Jack Leigh was an early inspiration in using the camera to tell southern stories. Lori Vrba was instrumental in helping me find my photographic voice. I am especially grateful to Mary Virginia Swanson, who has been an amazing mentor in

so many ways, and to Arthur Meyerson who continues to inspire my evolution as an artist. Lucinda Bunnen has been incomparably generous in both time and enthusiasm. John Dean is a masterful printer and superb collaborator. Thanks as well to Brett Abbott, Corinne Adams, Jan Fields, and Lisa Robinson for guidance and friendship.

I often share shooting expeditions with a group of photographers. We watch each other's backs, and I am a better photographer for what I have learned from them. Thank you to Once-ler, JustinDustin, Automatic, Shadowink, AmishDelight, Explicitly, Andyhal, LittleBrittle, CallMeJazz, Crypton, RedSky, and of course, Bennet.

The path that has brought us to this moment has been winding. One of my seminal joys has been the presence of Laura in my life. Extraordinary artist, Renaissance person, incomparable life partner . . . my art and my world are profoundly enriched by your presence. Also sharing the journey, my brother, Bruce, has been friend and advisor, critic and cheerleader. My sister, Cari, has been boundless in her enthusiasm and encouragement. Our family is blessed by the presence of their respective partners, Linda Rottenberg and Rodd Bender. And to Max and Hallie and Tybee and Eden . . . art projects with Nana are just getting you started!

Some of my fondest memories from childhood are of the times my father set up the slide projector and showed photographs from college days, navy travels, or recent trips with our mother. I learned early the power of photography to tell a story. My father tutored me through a succession of cameras from Kodak Instamatic to my first Nikon. My mother, an accomplished painter and talented arts educator, taught me the fundamentals of composition and the joys of creative expression. My artistic path began with their encouragement and enthusiasm, and this, my first book of photography, is dedicated to them.

Notes

Proud Past, Challenging Present, Uncertain Future

1 Marybeth Gasman, *The Changing Face of Historically Black Colleges and Universities* (Philadelphia: University of Pennsylvania Graduate School of Education, 2013), 5.
2 Charles L. Betsey, ed., *Historically Black Colleges and Universities* (New Brunswick, N.J.: Transaction Publishers, 2008), 1.

A Matter of Relevance

The epigraph quoting Le Goff is taken from "Memory," in History and Memory, trans. by Steven Rendall and Elizabeth Claman (New York: Columbia University Press, 1992), 98. The one quoting Nora is from "Between Memory and History: *Les Lieux de Memoire*," in *History and Memory in African American Culture*, ed. Robert O. Meally and Genevieve Fabre (Oxford: Oxford University Press, 1994), 7.

1 In her essay "And So They Are Ever Returning to Us, the Dead," Susan McKay writes, "Doherty is an artist who feels that he has an ethical responsibility to deal with the social and political context in the place that he lives. He admires W. G. Sebald, whose books combine narrative which is apparently documentary with photographs claimed by the story but that have a strangely random air about them. Critics struggle with the categorization of Sebald's work, but his own term: 'documentary fiction' seems apt also for Doherty's photographic work." Willie Doherty, *Unseen* (Oxford: Cornerhouse Publishers, 2013), 9.
2 Amiri Baraka, *Black Music* (New York: William Morrow, 1967), 180–211.
3 Carter G. Woodson, *Report of the Director of the ASNLH from June 1933 to July 1934* (Washington, D.C.: Associated Publishers Inc., 1934), 3.

Discursive Narrative

1 Excerpt from Morris Brown College Hymn, lyrics by student Milton Randolph (class of 1933) and scored by music faculty member Professor E. Waymon Hitchcock.

2 Marianne Pointner, "In Conversation with Susan Dobson," *Ontarion*, February 2, 2012.

3 Richard Feynman and Stephen Hawking essentially agreed with Einstein's bottom line position, publicizing their individual related conclusions of time and space as follows. Feynman: "we have not found this yet. That is, in all the laws of physics that we have found so far there does not seem to be any distinction between the past and the future." "The Distinction of Past and Future" in *The Character of Physical Law* (New York: Modern Library, 1994), and Hawking: "I still believe the universe has a beginning in real time, at the big bang. But there's another kind of time, imaginary time, at right angles to real time, in which the universe has no beginning or end." Cited in Gevin Giorbran, *Everything Forever: Learning to See the Timelessness of the Universe*, (n.p.: Enchanted Puzzle Publishing, 2006).

4 Kurt Vonnegut, *The Sirens of Titan* (New York: Delacorte, 1959). Vonnegut makes this comment through his character Winston Niles Rumfoord.

5 The item in Feiler's photograph is a Teletubby beanie based on the BBC originated characters for the preschool children's television show *Teletubbies* that aired from 1997 to 2001.

Contributors

ANDREW FEILER is a fifth-generation Georgian. Having grown up Jewish in Savannah, he and his art have been shaped by the rich complexities of the American South and of being a minority in the South: history and culture, geography and race, tradition and conflict, injustice and progress. Andrew's photographs have won numerous awards. His work has been featured in museums, galleries, and magazines and is in a number of private collections. He earned his master's in American history from Oxford University and his master's in business administration from Stanford University. More of his photography can be seen at andrewfeiler.com.

AMALIA K. AMAKI is an artist, writer, curator, and film critic who was professor of art history and visual studies for over twenty-five years at Spelman College, the University of North Georgia, the University of Delaware, and the University of Alabama. Her books include *A Century of African American Art: The Paul R. Jones Collection* and *Hale Woodruff, Nancy Elizabeth Prophet, and the Academy*. She has lectured extensively on art and film and has curated more than thirty art exhibitions, written more than twenty essays for art books and exhibition catalogs, and served on more than ten museum and university advisory boards. Her art has been shown in more than one hundred exhibitions locally, nationally, and internationally, and she was a National Endowment for the Arts fellow. She earned her doctorate in twentieth-century American art and culture from Emory University.

ROBERT E. JAMES has been president of Carver State Bank of Savannah, Georgia, since 1971. Since he became president, the bank has become one of the most significant businesses owned by African Americans in Georgia. He now holds the distinction of being the African American with the longest tenure of service as president of a commercial bank in America. He is a graduate of the Morris Brown College class of 1968 and earned his master's from the Harvard Business School in 1970. He has served as a director of numerous local, state, and national organizations, including service on the board of trustees of Morris Brown College. Currently he serves as chairman of the Savannah Economic Development Authority as well as a trustee of St. Joseph's / Candler Health System and St. Philip AME Church of Savannah.

PELLOM McDANIELS III is the curator of African American Collections in the Manuscript, Archives, and Rare Book Library at Emory University and an assistant professor in Emory's Department of African American Studies, where he specializes in sports history, visual culture and performativity, and black masculinity. McDaniels's research on black aesthetics and African sacred systems, as well as his most recent biography on the African American jockey Isaac Burns Murphy, *The Prince of Jockeys*, were funded by the National Endowment for the Humanities Fellowships. He earned his doctorate in American Studies from Emory University in 2007. Prior to his academic career, he played professional football.

LORETTA PARHAM is CEO of the Robert W. Woodruff Library of the Atlanta University Center. An active leader, scholar, and speaker, she has authored articles on HBCU libraries and archives, and is coeditor of *Achieving Diversity: A How-To-Do-It Manual for Librarians*. Among her many leadership roles she is cofounder and past chair of the Historically Black Colleges and Universities Library Alliance, board member of the Association of College and Research Libraries, trustee of the OCLC Online Computer Library Center, Inc., and board chair of the Georgia Humanities Council. She earned her master's in library science from the University of Michigan-Ann Arbor.

Credits for Historical Photographs

Morris Brown College Campus—Griffin Hightower Center, Fountain Hall & Gaines Hall—1986. *Morris Brown College Brownite Yearbook*, 1986, page 165, AUC Woodruff Library.

College Chapel—Fountain Hall—1947–1948. *Morris Brown College Brownite Yearbook*, 1947–48, page 50, AUC Woodruff Library.

Football Game—Alonzo F. Herndon Stadium—date unknown, AUC Woodruff Library.

Science Lab—Griffin Hightower Center—1970. *Morris Brown College Brownite Yearbook*, 1970, page 127, AUC Woodruff Library.

The Marching Wolverines—Alonzo F. Herndon Stadium—1972. *Morris Brown College Brownite Yearbook*, 1972, page 174, AUC Woodruff Library.

Classroom—Griffin Hightower Center—1976. *Morris Brown College Brownite Yearbook*, 1976, page 38, AUC Woodruff Library.

Men's Basketball—John H. Lewis Complex—1979. *Morris Brown College Brownite Yearbook*, 1979, page 202, AUC Woodruff Library.

Diving—John H. Lewis Complex—1979. *Morris Brown College Brownite Yearbook*, 1979, page 217, AUC Woodruff Library.

Students on Campus—1980. *Morris Brown College Brownite Yearbook*, 1980, page 22, AUC Woodruff Library.

Dining Hall—Middleton Towers—1980. *Morris Brown College Brownite Yearbook*, 1980, page 288, AUC Woodruff Library.